British Profile Miniaturists

FABER COLLECTORS LIBRARY
Edited by Kate Foster

ANTIQUE PASTE JEWELLERY *by* M. D. S. Lewis

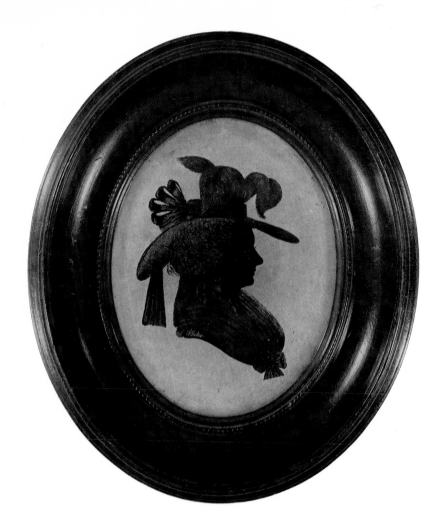

A. Frontispiece by T. Rider. A rare example of
English *verre églomisé*. His signature can be
seen on the truncation. (Page 66).

British Profile Miniaturists

ARTHUR MAYNE

Faber and Faber · London

First published in 1970
by Faber and Faber Limited
24 Russell Square London WC1
Printed in Great Britain by
Ebenezer Baylis & Son Limited
The Trinity Press, Worcester & London
Colour plates made and printed by
Fine Art Engravers Limited, Godalming
All rights reserved

ISBN 0 571 09208 X

© *Arthur Mayne 1970*

FOR PATRICIA AND STEPHEN

Contents

Illustrations

(For the measurements of the pieces illustrated, see the Note on Frames on p. 14. The measurements of a piece are only given separately where none of the three types of 'standard frame' is used.)

COLOUR PLATES

MONOCHROME PLATES
(AT THE END OF THE BOOK)

ILLUSTRATIONS

ILLUSTRATIONS

NOTE ON FRAMES

There were three varieties of frame that were particularly favoured by profilists, and may be considered 'standard frames'. Two of them were in use by Joliffe: the stamped brass frame surrounding his two portraits in plates 6 and 7, and the turned pearwood frame which can be seen in plate 12 setting off a portrait by Isabella Beetham. These two kinds were almost without competition from 1758 to about 1790 when they were joined, and gradually superseded, by the papier mâché frame. This was a rectangular black frame with a central oval of brass to set off the portrait. Since the effect of a number of likenesses so framed is inclined to be funereal, it has been thought advisable to mask out the papier mâché wherever possible, and present the portraits encircled only by the brass rims. However, plate 35 by Edward Ward Foster shows the full frame for the reason that the artist's name is impressed on a scroll above the crown which he incorporated in the hanger to remind the public that he was a Court profilist. Likenesses by Lea of Portsmouth [plate 46] also have to show the frame in full, for he was a reticent man, and brass is not reticent!

There were, of course, slight differences of size in these three varieties of frame. The average sizes follow, and according to the framer's custom the first figure is the upright and the second the horizontal measurement:

1.	Turned pearwood frame	6 × 5in.
2a.	Oval stamped brass[1] frame	5½ × 4½in.
2b.	Rectangular stamped brass frame, see plate 37	6½ × 5in.
3.	Papier mâché frame	7 × 5½in.

One artist who did not conform to general custom was John Buncombe, the military painter. He painted on card and supplied his work unframed—understandably, since his clients were men away from home. Many of their likenesses have been found in scrap books and transferred to standard frames.

ACKNOWLEDGEMENTS FOR PLATES

	Plate
London Museum	1
National Portrait Gallery	2
Victoria and Albert Museum	3, 4, 13, 14, 30, 32, 44, 70

[1] Or occasionally pewter.

ILLUSTRATIONS

Foreword

FOR far too long the eighteenth-century British profilists have been neglected. Their work has been consigned to the store-rooms of museums. When shown, it has been labelled 'silhouette', which is the equivalent of calling a fine Chambertin 'booze'. They have been vilified for not conforming to a set of rules made thirty years after they went out of business. It is time for a voice to be heard in their favour.

In case you have never heard of these people (and if you have you are somehow exceptional), here—on pp. 19-21—is a chronological table which will serve to introduce them to you. It is possible that you are already interested to the extent of collecting their work. If so, it will give you some assistance in identifying the authors of anonymous portraits. It will not replace knowledge of an artist's characteristics; nothing can do that. The table relies on the collector's ability to date a portrait accurately by costume or hair style, and recognize the method used. It indicates which artists using that method were at work at that date.

There are thirty-six artists all told, and the description 'British profilist' is not to be taken too pedantically. Frenchmen, Swedes and Germans have their place among these Britons. Compelled for varying reasons to leave their native lands and settle here to practise their art, they provided a useful spur to the native talent. Their point of similarity lies in the fact that they were all professionals, offering their service noisily or with discretion to such as were willing to pay for it. There was, as they very well knew, a high level of amateur ability with which they had to contend. In this regard they were almost invariably successful.

The dates attached to each name are those at which the artist is known to have worked, and where more than one date is known, the earliest is given. This is something over which the author has taken considerable trouble. If you happen to own a portrait bearing a date a year or two earlier than the one given in this book, don't blame him. Think yourself lucky to own an early specimen. Cross out his date and substitute yours, first making sure that you can rely on the authenticity of the inscription.

The thirty-six names, as you may have noticed, are contained within the years 1758 to 1820. During this span, and indeed for another fifteen years, there was no such thing as a silhouettist in these islands. These artists painted 'shades' and were called 'profilists'. In 1835 the word 'silhouette' made its impact on the country, and such was its power that it gradually obliterated and superseded the earlier names. But do not allow

yourself to think that the difference between a profilist and a silhouettist can be determined by a response to the question, 'Before or after 1835?' It is not as simple as that. Before that fatal year some very poor operators had appeared on the scene. Master Hubard, aged twelve, the 'clever little boy with a pair of common scissors', was a case in point. Some of his efforts were atrocious. Twenty years later, accumulated experience changed that story considerably.

From after 1835 the names of two artists spring to the mind who were capable of work fit to appear in any company. They were Beaumont of Cheltenham and Charles Hervé, but they were by no means the only ones.

So that while the artists of the high period start with an advantage, they are not in for a walk-over. In the final analysis it is quality which counts.

Don't try to learn the abbreviations at the top of the chronological table. Disregard them. Don't let them bother you in any way. If you treat them with contempt they will find their way into your head. You may feel quite happy with them in time!

Chronological Table of the Major Artists[1]

Abbreviations:

G	Glass painter	BP	Bust portraits
COMP	Painter on composition	FL	Full lengths
		CON	Conversations
PC	Painter on paper or card	GRO	Groups
		ITIN	Itinerant
CUT	Cutter	JM	Jewellery miniatures
BRO	Bronzing		
COL	Used colour		

							page
1. Joliffe 1758	72 St James's Street, London	G	BP				34
2. W. and J. Spornberg 1773	Bath	G	COL	BP	JM		35
3. Mrs Hudson 1774	Bath. Secards, Pall Mall, London	G	BP	ITIN	JM		37
4. Isabella Beetham 1774	4 Cornhill, London; 27 Fleet Street, London	G	PC	CUT	BP	JM	37
5. Sarah Harrington 1775	131 New Bond Street, London	CUT	BP	ITIN			42
6. Mrs Collins 1777	Bath. Duke Street, St James's, London	CUT	BP	ITIN			43
7. Mrs Lane Kelfe	Bath. 20 Duke Street, St James's, London	G	PC	BP	ITIN	JM	44
8. William Wellings 1778	3 Tavistock Row and 16 Henrietta Street, London	PC	BP	FL	CON	JM	45
9. Francis Torond 1778	3 Prince's Street, Leicester Fields; Wells Street, Oxford Street, London	PC	BP	FL	CON		45

[1] For further details, see chapter 4.

			page
10. William Hamlet 1779	17 Union Passage, Bath	G BP FL ITIN	47
11. Walter Jorden 1780	Address unknown	G BP FL	47
12. Richard Jorden 1780	Address unknown	G PC BP FL CON	47
13. John Miers 1781	Lowerhead Row, Leeds; 162 and 111, Strand, London	COMP BP ITIN JM	48
14. John Patey 1781	London	COMP BP ITIN	60
15. S. Houghton 1785	South Bridge Street, Edinburgh	COMP BP JM Miers school	60
16. J. Thomason 1785	Dublin	G COMP BP Miers school	61
17. Mrs Lightfoot 1785	Liverpool	COMP BP ITIN Miers school	61
18. A. Charles 1786	130 Strand, London	COMP PC BP CON JM	61
19. H. Redhead 1787	Upper Norton Street, Fitzroy Square, London	G BP	62
20. J. Smith 1787	Edinburgh	COMP BP JM Miers school	62
21. Carl Christian Rosenberg 1788	Bath. Court painter. Windsor	G COL BP FL GRO JM GILDING	63
22. Edward Ward Foster 1788	Derby. Windsor. 125 Strand, London	PC CUT COL BP	63
23. W. J. Phelps 1788	Drury Lane, London	G COMP PC CUT COL	64

1. The Profile takes Precedence

ACCORDING to popular belief, the eighteenth century was distinguished from all others by its Elegance and Good Taste. So widely has this come to be accepted that another characteristic of the eighteenth century has almost escaped notice. Not only was it the Age of Elegance it was also the Age of Credulity. No story was too tall for it to swallow!

For the artist it was a period with pictorial opportunity everywhere at hand. It did not enjoy the advantages conferred by that contradiction in terms the 'artist-photographer'; so, philosophically, it did without him. Nevertheless, the portraiture existed that he would have claimed had he been prematurely invented, and for that reason artists equipped with varying methods competed to carry it out. Most of them were modellers of one sort or another—wax modellers, ceramic modellers, or modellers in glass paste— but before long they were joined by a group consisting mainly of painters who called themselves 'profile miniaturists'. They painted what came to be known sometimes as 'profile miniatures', or more colloquially as 'shades'.

As they gradually became absorbed among the earlier contenders it began to be noticed that almost without exception these practitioners, whatever their degree, all concentrated on the profile. From this originated the belief that in the profile lay the key to individual character, plain for all who could read. The idea caught on like wildfire. It was the kind of intellectual fallacy, at that time irresistibly popular, to be discussed solemnly and swallowed whole. Let us trace it from its beginnings.

It all started with a young man from Dieppe. He was a Huguenot and one of the many refugees who fled to this country soon after the revocation of the Edict of Nantes in 1685. He claimed that his name was John OBrisset but it was suspected that he was born Aubrisset in his native country. He worked in pressed horn, and also in tortoiseshell on which he carved portraits and designs.

Feeling that a touch of mystery was no drawback but rather an asset in business, since it stimulated curiosity and interest, he would tell no one where he learned these particular skills. They were previously unknown in England. Under questioning he would disclose no more about himself than that his family were ivory workers in Dieppe. This was no help to the curious, for there was no pressed horn or tortoiseshell work done in that part of France either.

Possibly because he was an admirer of royalty, or maybe because he thought their portraits were conducive to increased sales, these were the subjects with which he chose

23

to decorate the majority of the plaques and snuff-boxes in which he specialized. His record includes all the English monarchs from James I to George II (there are eight of them), and twenty-five examples are devoted to Queen Anne, the Protector, Queen Henrietta Maria, Queen Mary II and Queen Caroline, Prince George of Denmark, Prince Philip of Spain and Peter the Great of Russia [1].[1] The work was done in low relief and they are all depicted strictly in profile.

Here was the start of a trend, and it was carried on by the next wave of artists, the wax modellers. They were T. R. Poole, Patience Wright, Catherine Andras, T. Hagbolt, Peter Rouw, Isaac Gossett, and William and John Flaxman. With many others they concentrated on the profile for their plaques in low relief.

We illustrate the kind of work for which they were celebrated with a portrait of Princess Charlotte, daughter of George IV, typical of, and attributed to, Peter Rouw [2]. The smooth pink wax, the high relief, the dexterous and effective undercutting are all marks of his work, which was exhibited at the Royal Academy between 1787 and 1840.

The trend of the profile was carried forward again by Josiah Wedgwood's series of portrait plaques, the 'Illustrious Moderns' [4]. They were in bas-relief on solid or jasper-dip grounds, and totalled between three and four hundred plaques. 'Moderns', for Wedgwood, was a word which allowed enough latitude to include Chaucer.

Here we are brought to recognition of the fact that wax-modellers and ceramic workers cannot be tidily labelled in separate compartments. On a project of this kind they are interchangeable, for the first model for the ceramic product is made in wax or, just occasionally, as a terra-cotta relief.

Isaac Gossett is one of the six modellers, all of great ability, who were engaged by Wedgwood to work on this series. The others were Joachim Smith, William Hackwood, Eley George Mountstephen, John Flaxman and James Tassie.

Gossett became a member of the Incorporated Society of Artists and exhibited twenty-four wax portraits with them between 1760 and 1778. He is sparing of signatures, but to counterbalance this has an individual and recognizable style. Like many other wax-modellers he experimented with the composition in which he worked, and more successfully than some, for he invented one which resisted stains and discolorations and retained its freshness indefinitely. He varied its colour from pale grey to ivory, lemon and palest possible pink. The outer edges of his likenesses sink gradually into the background; there is no sharp rise. The background is frequently of wax of the same colour as the portrait, or glass painted claret-colour, dark green, dark blue or black. There is nothing slap-dash about his modelling. Every detail is etched with delicate care.

William Hackwood was principal modeller to Wedgwood from 1769 to 1832, a singularly impressive record of sixty-three years' service.

Eley George Mountstephen came from Ireland and on arrival in London found employment with James Tassie who then had premises in Leicester Fields. Mount-

[1] References to the plates are in square brackets.

B. W. Phelps of Drury Lane. Portrait of a lady.
Painted on composition with a faint introduc-
tion of colour (Page 64).

stephen was a fine modeller, but less successful in mixing composition, for the white wax which he used has developed a tendency to flake away.

John Flaxman is in a different category from the others, since his reputation depends not solely on his ability as a portraitist but also as a sculptor and draughtsman. Indeed, he was something of a prodigy. He was the son of a plasterer, and at the age of twelve gained the first prize of the Society of Arts for a medal. He studied at the Royal Academy Schools; first exhibited at the Academy in 1770 at the age of fifteen; and about five years later started to work for Wedgwood. In 1787, with the help of Wedgwood, he went to Italy, where he remained for seven years, and made a great reputation for his models, drawings and designs.

Joachim Smith modelled his likenesses in flesh-pink composition, delicately shaded. There are portraits by him of the Prince Regent and Frederick, Duke of York (aged four and three), to be seen at Windsor.

James Tassie is principally remembered as a worker in white vitreous paste, now known as 'glass paste' which he invented in conjunction with Dr Henry Quin. It was analysed as glass paste towards the end of the nineteenth century. He called it his 'white enamel paste' and used it for medallion portraits [3] and for reproductions of gems. He took premises in Great Newport Street in 1766, and the following year exhibited two wax models at the Society of British Artists. At their next exhibition he showed two portraits cast in his white enamel paste which at once became extremely popular. Incidentally, he reproduced in this paste a portrait of Queen Anne from the original model by O Brisset.

The use of Tassie's paste for the reproduction of gems brought him into contact with that colourful character Rudolf Eric Raspe, for whom he executed a great number of reproductions. Raspe, born in Hanover and educated at Göttingen and Leipzig, became a professor at Collegium Carolinum in Cassel, and Keeper of the Antique Jewels and Medals of the Landgrave of Hesse. He was the author of the original *Baron Münchausen*, and in 1775 visited England bringing with him the script of that ingenious work which he subsequently published here. He also brought, regrettably, the antique jewels and medals of the Landgrave of Hesse. After all, he was their keeper! His career in England is not without its interest but may be hardly to the purpose of this book.

Tassie, then, found himself faced with a problem caused by the sudden wave of popularity of his white enamel paste portraits. He had to devise a means of producing them in quantity. A number of experiments brought the solution. He would model a likeness from life in wax. From it he would cast a mould in plaster of Paris, and from this mould he would take a relief in the same material and use it to impress in glass paste the matrix for glass paste copies. When you next examine one of his portraits compare its apparent simplicity with the complexity of the processes through which it has passed.

Throughout the period under consideration these minor arts—horn and tortoiseshell pressing, wax modelling, glass paste and ceramic portraiture (and the work of the

profile miniaturists, which is now to receive attention)—were practised side by side with miniature and oil painting. These latter, by the combination of colour and what is known to the painter as 'modelling', could deal with the sitter's full face satisfactorily. The former found their best results in the profile. In Wedgwood's bas-relief decoration devoted to classical or mythological subjects, the full face may appear in order to give variety to a group of figures but for portraiture the insistence was on the profile.

Individual artists rebelled and tried experiments. Tassie produced a portrait of Frederick the Great as near full face as possible and by no means flattering. It can hardly have met with the original's approval. Tassie did not persist. OBrisset had displayed James I squarely on to the observer, and seemed doubtful of the result. He tried a curious experiment in the double portrait of Charles I and Henrietta Maria. The queen is seen in profile (by no means her best aspect) while the king turns three-quarter face towards us with an expression of considerable disdain! To a present-day observer, conditioned to deodorant advertising, the artist has failed in his purpose! OBrisset may have thought so too, for after that he kept strictly to profiles.

As a consequence, throughout the century the public was subjected to a steadily increasing bombardment of side-face portraits. It is little wonder that in that credulous age they came to believe that the character was better displayed and the inner attributes of a subject more clearly revealed by the profile than the full face.

If this seems unduly credulous it may be well to recall the wager made by the Duke of Montagu in 1749 that 'an advertisement for the most impossible thing would fill a play-house'. An advertisement accordingly appeared, stating that in the New Theatre in the Haymarket a performer would, 1: play the music of any instrument on a common walking cane, singing at the same time, 2: walk into a wine bottle, which might be examined by all while he was within, and 3: tell all who care to come masked who they were. The theatre was packed to the doors.

At that time the entire population of the country was seven million people. Today's comparative density of population together with its improvement in communications may have the effect of sharpening people's wits.

However that may be, the time was clearly ripe for the publication of John Caspar Lavater's *Essays on Physiognomy* the English translation of which appeared here in 1794. It expounded the theory that physiognomy was a science which revealed human character in its entirety. Lavater was a native of Zurich and his treatise, which was according to the title page 'designed to promote the knowledge and love of mankind', was published in five durable quarto volumes, totalling around 1,700 pages.

In Lavater's own definition physiognomy was 'the science of discovering the relation between the exterior and the interior—between the visible surface and the invisible spirit which it covers—between the animated perceptible matter and the imperceptible principle which impresses the character of life upon it—between the apparent effect and the concealed cause which produces it.'

26

To help him demonstrate the truth of his theories, Lavater included in his instructive work some eight hundred illustrations of subjects he had studied as a physiognomist together with the deductions he had made. Since he had plenty of space to operate in he did not confine his studies strictly to the profile, yet the proportion not in profile is very small indeed. There they all are, fashionables and criminals, justices and felons, animals and imbeciles, neatly ticketed and labelled for your enlightenment. Whether Lavater has any disciples today there is no means of knowing, but his book was highly regarded in his day; translated into English and French it made something of a noise in the world. His theories provoked thought and he had quite a success in his time.

So far our attention has been confined to the methods of portraiture which preceded the profilists and were in competition with them on their arrival. These methods had one thing in common, they all produced work in bas-relief; and in this the profilists had no interest whatever. They had a considerable variety of methods within which they operated—all of which all made the profile the obligatory angle of portrayal. So, happily unconscious of the part they were playing in a larger scheme of things, they settled down to contribute their effort to John Caspar Lavater's eventual success.

2. Methods and Machines

THE shadow portrait has been known to man since it provided entertainment for the earliest of his simple ancestors. The tomb paintings of the ancient Egyptians carry the signs of its influence. So do their relief sculptures. These signs are also evident in the delicately executed designs on Greek and Etruscan pottery. It is clear that the Greeks knew how to make a likeness by copying the outline of a shadow cast by the sun.

In Europe the development of shadow portraiture was slow until paper became generally available. The history of paper manufacture is one of long pauses between short leaps forward; its first use in Europe was probably in the twelfth century, when it was of coarse uneven quality which evoked no enthusiasm at all. Over three centuries went by before an English manufacturer appeared, prepared to make paper, and courageous enough to allow his name to be attached to the product. John Tate started work in Hertford late in the fifteenth century. His output was of a more serviceable variety than had hitherto appeared. When Sir John Spillman erected a paper mill at Dartford in 1589 it was felt that progress was really being made at last. Quality was improved and price reduced to an extent that brought paper into much more general use.

Thus by the seventeenth century the method of taking a profile portrait on paper by placing a lamp or candle to throw a shadow on a screen began to be practised by amateurs. In 1699, it has long been said, a Mrs Pyburg took the profiles of King William and Queen Mary. She may well have done so, and if she did it was an important event in the chain of amateur effort which led to the professional take-over that occurred in the middle of the following century. The amateurs had developed methods of cutting and painting, and while some of the professionals would be content to go along on these lines, there would eventually be considerable diversity. The first professional on the scene brought an entirely new method with him.

Of those who started as cutters possibly the most remarkable was Isabella Beetham. Her work in that method demonstrates her sharpness of perception, and she later went on through painting on paper and card to become a brilliant glass-painter. Sarah Harrington, another cutter, succeeds in giving us a relative softness of execution, and Augustin Edouart achieves remarkable precision.

The cutters are considerably outnumbered by the painters and the latter seem more inclined to accept sensible rules. While cutters made no limitations on a portrait's size, and required no uniformity in the way it should be framed, the painter accepted from the

28

beginning that a bust portrait should be an oval approximately two-and-a-half inches by three-and-a-half inches and enclosed in either a turned pearwood or a stamped brass frame. Towards the end of the century, in approximately 1790, both these types were discontinued and replaced by rectangular frames in papier mâché (see p. 14).

The opinions of the painters in respect of frames have been firmly endorsed by today's collectors. An original frame is regarded as an integral and essential part of a transaction. At Joliffe's exhibition in 1758, which placed this minor art on a professional basis, his exhibits were framed in pearwood and stamped brass frames, which thereafter persisted throughout the century.

The painters worked on paper or card, which discoloured through the action of light; on composition, which meant a prepared block of plaster of Paris that suffered no change through the action of light and has in many cases retained its original freshness for the better part of two hundred years; and on the underside of convex glass.

Recently I was surprised on entering one of our more respected auction galleries to find an entry in the catalogue which read, 'A Pair of Portraits by Mrs Beetham on wax.' Profilists did not paint on wax. They backed a painting on convex glass with it.

For jewellery miniatures ivory was used, and there was one profilist who painted the normal bust-size shades on ivory.

These, then, are the basic methods, but almost every permutation must have been tried. The simplest is of course the cut-out portrait which has been touched with gold paint or 'bronzed'. The most complicated and completely satisfying are those done by W. Phelps in which ladies with black faces wear apple-green dresses and puffed white turbans, their pouched fichus challenging the buff frilled cravats of the men. This is elaboration when described but perfect restraint when seen. It would be a bold man who made a judgment on the rival merits of the painters on composition and on convex glass; and who was prepared to adjudicate between a fine Miers of the Leeds period and an equally fine Beetham on glass. If the competition became a three-cornered one by the addition of a Phelps such as has been described he would need every atom of his courage.

At an early stage in the study of profilism the mention of 'Machines for taking Likenesses' is encountered. The machines in question are intended for professional operators but it is a fact, indicative of the public interest, that throughout the period of the profilist's popularity, and until he was succeeded by the photographer, there were on the market a number of versions intended to gratify proud papas who might wish to take the profiles of their families and friends.

The nature of the machines varied considerably. From the day when the Revd. William Mason wrote to the poet Thomas Gray informing him that 'Mr Joliffe is a bookseller's son in St James's Street who takes Profiles *with a candle* better than anyone', the necessity for a 'machine' became apparent. Simple as the tracing of an outline thrown on a sheet of paper by a candle may seem, two difficulties immediately became apparent: first, the sitter must be frozen into immobility; and second, during the proceedings

there must be no emotional outburst, movement or laughter which might disturb the atmosphere, because the *candle flame must not flicker*. In the early days it was the purpose of the machine to overcome these difficulties. Later it went on to do actual cutting, which it accomplished with such rigidity as to render its efforts nugatory.

It must, of course, be remembered that there is a considerable difference between what, in the eighteenth century constituted a machine, and our conception of a machine today. At that time a *pantograph* was a machine, and pens, pencils and brushes were Apparatus.

The earliest machine consisted of a high-backed arm-chair for the sitter, a cross-bar on which to rest his hands, a frame for the sheet of oiled paper which could be fixed vertically on either arm of the chair, and a reflecting screen for the candle. This would probably contain a mirror to boost the light. The operator would sit and trace the outline, which would then be an 'original shade'. It would be reduced with the help of a pantograph and filled in with a black paint, the constituents of which were a closely guarded secret. Transparencies, feathers and such decorations would be added, including fashionably dressed wigs for those who 'came in their own hair'. The difficulty of ensuring the sitter's immobility was overcome among some of the later inventors by the use of a system of head-clamps, leg-irons and handcuffs reminiscent of the days of the Inquisition. It was found that they gave poor results and discouraged clients.

A patent for a machine of this kind was granted to Charles Schmalcalder in 1807 which, judging from the diagram accompanying his application [5], could be guaranteed to scare the strongest minded and reduce the nervous to gibbering imbecility. Its most noticeable feature was a hollow rod made of copper or brass extending to a length of twelve feet. The recording end of this rod was secured. The operator held the rod at its centre under his arm; it was heavy and needed considerable strength to guide it. The other end, which most interested the victim, since it was to be passed (lightly, he hoped) over his face, held a long steel needle or tracer. The purpose of this monster was to cut out profiles from copper, brass, hardwood, card, paper, asses' skin, ivory and glass. Just for the record I must admit that I have never seen a desirable profile cut from ass's skin.

The *Physiognotrace*, invented by a Frenchman, G. L. Chretien, for his own amusement, and turned to good account when, as a musician, he fell on hard times, found its way to this country and into several studios, notably that of W. Bullock of Liverpool. His trade label described him as 'Jeweller, Silversmith and Chinaman to H.R.H. the Duke of Gloucester' and gave his address as the Liverpool Museum. The museum was a superior example of what was known as a 'raree show' consisting of some six thousand exhibits. There were items of Antiquity, Natural History and Fine Arts. It was brought to London and enjoyed a successful season in the neighbourhood of Baker Street. With the aid of the physiognotrace Bullock successfully produced some very competent portraiture. But how much of the credit belongs to him and how much to the machine is a very difficult question to answer.

The *Ediograph*, a machine for taking miniature profiles, was invented by John Oldham in 1807 and seems to have met with very little success. He was a miniature painter, and the inventor of a process for engraving banknotes. This invention was acquired by the Bank of Ireland and the ediograph probably made Oldham more in banknotes than it made profiles.

Prosopographus, advertised as 'a lifeless image endowed by Mechanical Powers to draw Likenesses of the Human Countenance', was a fairground trick to wheedle shillings out of the pockets of simpletons.

Limomachia, invented by 'Pinion', was a skit on these machines.

John Caspar Lavater, of course, had his own theories on the subject of the machine, and plunged into what then passed for scientific jargon, the interaction of cylinders, prisms, pyramids and cones, in a fruitless endeavour to elucidate them.

One of the more successful machines was that patented by Sarah Harrington. It relied on the principles of the *camera obscura*. More will be said about it later under her name.

To many people the idea of employing a machine robs the process of any suggestion of artistry. This was, it goes without saying, the least expensive form of portraiture, that being one of the reasons for its popularity. It was informal: the sitter dropped in as inclination dictated and without an appointment. As a consequence many studios were subject to pressure that necessitated having several operators in attendance. The one that springs to mind is that of John Miers at 111 Strand. Here the pressure must have been particularly high, yet you may, over a period of years, examine many hundreds of the studio's likenesses without finding one which fell below his own very high standard.

To complicate further an already complicated matter, it should be said that there were many artists who had not the slightest need to use any mechanical appliance whatever, and that nevertheless some of these employed a machine because that particular brand was thought of highly by their clientele. It led to conversation and verbal advertisement, and so was likely to bring them other sitters.

As previously stated there were, in addition to the machines employed by the professional profilists, a number which were made for those who wished to entertain their friends or even make portraits of themselves. One of these was the subject of an advertisement issued by a Mr Brooks in 1785. There is no traceable record of the excellence (or otherwise) of his machine's performance, and it is to be hoped that he overcame its complicated difficulties more successfully than he did those of grammatical construction! Here is what he says:

LIKENESSES.

To the Ingenious World. There is now to be had a Mathematical Instrument, by which any Person for the expence of half a guinea may produce Miniature Profiles of themselves or a thousand different persons in the most correct manner. In short it answers every intent

of not having any of its complicated difficulties and not one eighth of the expence and are so portable as to lay in the compass of a foot rule. The Public are assured that the above are the Original ones, but their great Utility and Demand for them has induced Persons to make very indifferent copies, for if they are not put together with mathematical exactness they can never work true.

All orders sent to the Portfolio Manufactory No. 3 Coventry Street (the Golden Head, next house to the corner of Oxendon Street) will be executed with engraved directions so as to render the operation perfectly safe. N.B. The above house is the only manufactory for portfolios in London, where may be had all sorts of prints, drawings, writing, &c., &c., to any size. Likewise a collection of modern drawings.

3. The Men and the Women

FOR the devotee of fashion the second half of the eighteenth century brought modes both masculine and feminine which, while elevating their wearers to a high level of sartorial distinction, at the same time condemned them to a low level of physical comfort. In the upper strata of society the corset was *de rigeur*, as often for the male as for the female. Shoes were tight. Cravats held the head unbearably high. Wigs were heavy and hot. As compensation for their discomfort they had the ever-present consciousness of their pictorial quality. They kept the fashionable painters busy; the painters of miniatures, too. The trouble was that there were not enough of these artists to fill all the demands. It was at this opportune moment that the profilists arrived. The peacockery of the male of the upper and moneyed classes, the time and care he lavished on his appearance, and the desperate ingenuity of the female in her attempts to keep pace with him made some new form of artistic recording almost a necessity.

In his *Table Talk* (1821), Hazlitt says, 'There is a natural desire in the mind of man to be the object of continued attention, to have one's likeness multiplied.' This was the time when that desire was felt to the full. Patronage came from persons of assured position, leisured followers of a fashion which exalted them to high decorative distinction. Silks, satins, brocades and lace flattered their wearers and lessened the penance of the painter's sitting. Royalty graciously led the way, and where royalty led they were quick to follow.

At first the fashionable came to make their acquaintance with the new portraitist and his unaccustomed methods a little superciliously. They were inclined to be more than usually patronizing, for this was an inexpensive sitting for one's likeness, but they gradually lost the tone of patronage with interest in the new procedures and pleasure in the results. The visit to the profilist added variety to the sometimes monotonous round of morning calls, and after all it was much more entertaining to meet one's friends at Mr Rosenberg's, where one was likely to hear the latest Court gossip, than to hear the oft repeated tale of Lady Diana's ailments.

In this manner the profilist found his niche in English upper-class life. Here this minor art attained the dignity of professionalism. Other countries were quick to follow. In the next chapter, we shall start by considering the pioneer who, during a limited span of time, might have claimed to be the only professional profilist in existence.

4. The Major Artists[1]

1. Joliffe

G BP

IN THE year 1758, a young man named Joliffe, the son of a bookseller in St James's Street, contrived the first variation on those early shadow portraits painted on paper and card. In an exhibition at White's he showed how effective portraits painted on glass could be. His exhibition laid the foundations for half a century of shadow portraiture where standards reached an unsurpassable level of elegance and grace. If one variation could be made and found acceptable why not another? It was simply a matter of time for the variety of methods to multiply bringing new sponsors with them.

Joliffe's exhibition was a great success. Of that there is not the slightest doubt. He took some four or five hundred portraits including one of Prince Edward. He doubled his prices. He had arrived. One of his patrons, a witness of repute, is on record as asserting that 'he has got literally above a hundred pounds by it!' Not a very impressive sum you may think, and in terms of modern spending power you would be right. Master Joliffe, however, could buy a dressed chicken or duck for sixpence, a bottle of rum or gin for the same price, and a bottle of French brandy for ninepence. On the other hand if he hankered after a pineapple it would cost him a guinea. Maybe he didn't hanker!

Joliffe's method of presentation was distinctive, and merits description, since it must be remembered that his predecessors had either cut from or painted on paper [6, 7]. He painted on the back of flat glass, which had a surrounding oval black border pierced with small circles that were connected by interlaced tendrils and gilded. Details of hair and costume were similarly treated, or left open to show the pale silk backing the picture. His device of the looped curtain above and to one side of the sitter, simply suggesting a rich interior, was copied by a number of his successors who also unanimously adopted the oval stamped brass or pearwood frames in which he enclosed his finished productions. To the unaccustomed eyes of his clientele they must have represented the very luxury of portraiture.

Only two things remained for Joliffe to do to complete a working formula for his successors. First, to devise a trade label which would identify the artist and set the seal on his work. It would announce the address of his studio, his scale of charges, and the high quality of his portraiture to all persons likely to be interested. This he did. A copy of it

[1] For the abbreviations, see p. 19.

34

would be a rarity in any collection. So rare is it that it seems likely he introduced it only towards the end of his career as a profilist, an event for which we are as yet unable to give a date.

The second thing, and this he omitted to do, was to issue an informative advertisement of his wares. Our knowledge of these artists comes in two ways: through their trade labels and through their advertisements. The labels give basic facts and occasionally indicate idiosyncrasies. The advertisements tell more about the man. Joliffe seems to have been a modest fellow who could not imagine that posterity would be interested.

The success of his exhibition did not result in an immediate rush of imitators able and willing to step into his shoes. We have no certain indication of how long he continued to practise. It is possible to infer that he worked well into the 1760's but both he and his clients were regrettably shy of attaching dates to his work, so that there is no certainty in the matter. It may be that he inherited his father's bookshop, which continued to flourish until somewhere near the end of the century. In such a case he would probably have been obliged to forego further excursions into profilism except perhaps as a matter of favour.

No new name appears during the decade of the sixties. Desmond Coke mentions George Rouse of the Bridge Ward Coffee House under the Piazza in London Bridge who, as early as 1765, offered his skill at the price of half-a-guinea. He describes his work as 'Gentleman and Ladies Pictures' and there is no mention of profiles. In many years of searching no example of his art has come my way and I have, rightly or wrongly, written him off as a possible profilist. The portrait of a man in a wig and a cocked hat is recorded by Mrs Nevill Jackson, painted on card and bearing the signature 'Watkin' and the date 1760. Nothing further is known of Watkin, and there is no clue whether he was an amateur or professional. No other example of his work has appeared in the thirty years that have elapsed since he was recorded. Before we assume that, as far as the profilist is concerned, the 1760's was a moribund decade, let us consider that in the year 1792 the profilist A. Charles claimed to have completed 11,600 portraits. Today his work is tantalizingly rare. There could be an even greater rarity in the case of an artist working a quarter of a century earlier.

2. W. and J. Spornberg G COL BP JM

Emerging from the slight haze which envelops the 1760's in regard to profilism, we find a practitioner of the art working at Bath in 1773. His name was W. Spornberg and he was a member of a Swedish family settled in this country. What Christian name the 'W' stands for is unknown. His portraiture is immediately recognizable and signed very clearly and definitely: 'W. Spornberg Invenit Bath', followed by the date [8], which may be 1773 or up to twenty years later. Since he clearly had a comfortably settled practice in Bath it is

not surprising to find that during those twenty years he had at least four known addresses in that town.

Despite the fact that Spornberg can hardly be described as painstaking his results were vivid reminders of the Etruscan art which delighted the classically conscious eighteenth century. He painted 'hollow' on the back of convex glass, filling in the background with black from which he scraped away a roughly designed decorative border. A few lively touches with the brush indicated hair and features and the work was then finished off with a liberal coating of red pigment. Framed in the rich gilt oval of the period, we have a highly decorative portrait in Venetian red against black, instantly attributed to this artist.

Modern writers have divided opinions about Spornberg. Some have condemned his work as ugly. Others have compared it to beer-bottle labels! This is a crude comparison, and could only have been made by a person unacquainted with Etruscan art. However, while beauty is a matter of individual opinion, differences will not be avoided. A minimum of research might well bring to light some who 'can't stand' Rembrandt or find Rubens 'disgusting'.

Another member of the family who signs 'J' Spornberg (the 'J' has identified him as Jacob) is responsible for a more usual type of likeness in black on glass [9]. Despite his lack of colour, his work succeeds in capturing much of the élan of the Etruscan portraits and is perhaps even more a collector's prize. He is also on record as the painter of a conversation piece.

The shades painted by both these artists are highly appreciated today, and the appreciation is duly reflected when they are offered in the market-place. But what influence did their painters exert on this movement when it was seeking momentum for another advance? It may seem to you that the five ladies we are next to consider did more to help it along than did the stay-at-home Spornbergs.

The trade labels of these early artists have usually something of interest to reveal, but that of W. Spornberg is very rare and very reticent.

BATH

Mr SPORNBERG

Miniature Painter
2 Lilliput Alley.
Profiles painted on glass in the
neatest manner.

2 Lilliput Alley is the address on the 'Black Spornberg' painted by Jacob which we reproduce [9]. The other addresses which have come to light in this connection are:

5 Lower Church Street, Bath,
North Parade, Bath,
5 Bond Street, Bath.

FIVE LADIES

3. Mrs Hudson

G BP ITIN JM

A recrudescence of the art was now about to take place led, let the feminists take note, by five women. The first was Mrs Hudson who in 1774 advertised her work in the *Bath Chronicle* [10, 11]. Purely by the accident of birth she was the first woman to specialize in jewellery miniatures. She was born a Miss Chilcot, daughter of Henry Chilcot, goldsmith and jeweller, of Greek Street, Bath. As we might expect, the 1774 advertisement announced her readiness to 'take Likenesses as usual in their own hair for Rings, Lockets and Bracelets.' Which would, of course, be manufactured by papa!

While Mr Hudson appears to have made no impact on history, his wife travelled extensively, and in 1775 was advertising in the *Birmingham Gazette* that she had taken over one hundred and fifty likenesses in that city. Apart from her jewellery miniatures she painted miniatures in colour, and made such wax models as might be required by her clients. Her London address was at Secard's in Pall Mall, and she was advertising as late as 1796; so she may be fairly described as an artist of the last quarter of the century.

Mrs Hudson was one of the early artists to use a trade label [11]. That she had seen a label issued by Joliffe or Spornberg is possible. It is equally possible that she had not. A few years later when John Miers got into his stride, a curious uniformity sprang up in these labels as one profilist copied the ideas or wording of another.

Clearly Mrs Hudson took nothing from Spornberg who proclaimed that he painted profiles on glass in the neatest manner and let it go at that. Joliffe was even more reticent, divulging little more than his name and address. So that when she sat down to compose her label she was under no outside influence and her opinions of the relative attractions of what she had to offer were very clearly stated. She begins in block capitals:

<div align="center">

MODELS
IN WAX
and Striking Likenesses,
in profile or in colours
executed in a superior stile
of Elegance and Fashion by
Mrs Hudson from The late Secard's, Pall Mall, London.

</div>

The models were first favourite, the profiles second, the coloured miniatures an also ran.

4. Isabella Beetham

G PC CUT BP JM

This lady, a keen contender for top place among the profilists, was born Isabella Robinson in 1750. In 1770 she ran away from home. Whether she had at that time met a young

itinerant actor named Edward Beetham, or whether she fled for some less important reason has not been discovered. Suffice it to say that she married him some three years later. He was six years her senior and, as a rogue and vagabond (at that time his legal description), he had incurred the displeasure of his family who were landed gentry. The young couple, who had both cut adrift from home ties without overmuch consideration of ways and means, had a hard struggle to exist in the early years. But not for the first time, under duress a talent was brought to light. Isabella discovered a gift for cutting black-paper likenesses [13].

Edward Beetham had some acquaintance with the actor Samuel Foote. The latter had by this time turned theatrical manager, having built the new Haymarket Theatre. On hearing of Isabella's discovery he was not slow with encouragement and indeed gave her some help to turn her gift to professional advantage. Thus it happened that, dating from 1774, her earliest cut-paper portraits may be found with addresses of lodgings in Clerkenwell and Holborn. Before very long, and still suffering from a heavy attack of sentimentality in the early days of her marriage, she decided that business interests would best be served by the addition of a trade label to her work. It was not the first trade label issued by a profilist. Joliffe had already used one, and Spornberg may have done so, but their labels confined themselves to bare essentials. Isabella's did not by any means do that. She took flight into lyric poetry in the service of Mammon:

> By application leagued with Good Natural Gifts
> Mrs Beetham has enabled herself to remedy a Difficulty
> much lamented and Universally Experienced by
> PARENTS, LOVERS AND FRIENDS.
> The former, assisted by her Art may see their Offspring
> In any part of the Terraqueous Globe;
> Nor can Death obliterate the features from
> their fond Remembrance.
> LOVERS the Poets have advanced, 'Can waft a sigh from Indus
> to the Pole'.
> She will gratify them with more substantial though Ideal
> intercourse by placing the Beloved Object to their View.
> FRIENDSHIP is truly valuable was ever held a Maxim.
> They who deny it have never tasted its Delicious Fruit
> or shed a sympathising tear . . .

There was more in the same strain and it was, of course, most edifying. Unfortunately the space given up to portraiture was limited, and governed that allotted to its praise. The literary matter needed editing. It usually got it from the framer's scissors.

Now while we may chuckle at Isabella's poetic eloquence let us not overlook the axiom that the most important, the most revealing words in that profilist's trade label are

contained in the first sentence. 'By application leagued with Good Natural Gifts' sums the lady up nicely. She had the gifts, as is evidenced by her early cut likenesses. By the time she was ready to take a studio at 4 Cornhill, she had applied herself to painting. Her clients there could still have a cut-out if they wished, but the attraction was the portrait painted on card, of which her likeness of a fashionable young lady is an excellent example [12]. For me these are always her Cornhill portraits, although Fleet Street saw them produced in gradually decreasing numbers alongside what she called the 'portraits on chrystal' with which she planned to beguile them.

The modish young lady [12] is Sarah Anne East at the age of fifteen. The experienced collector will immediately notice these points of style which constitute a signature, and recurred as the profilist's later painting settled into what may be called the Beetham manner.

A young lady at the time that Miss East sat for her portrait wore an under- as well as an overskirt. These were of the same, or of contrasting colours and the overskirt would be 'cut on the diagonal'. Here it becomes regrettably necessary to bring to light a frequently repeated example of feminine deceit. It was the habit of many ladies to stuff the space between the under- and the overskirt with crumpled paper formed loosely into balls. Apart from improving the appearance of the garments, the paper rustled as the wearer walked. What strange whispered secrets that rustling conveyed! It must at once be established that there is no intention of imputing such dubious behaviour to Miss Sarah Anne East. Isabella Beetham, however, was concerned with nothing but appearances. The puffed-out overskirt, and the arm which rests weightlessly on it, are found confidently repeated throughout the Fleet Street glass paintings. They must have given satisfaction to countless sitters. They are a formula conveying gallant beauty in the Beetham manner.

To leave the matter of painting to take care of itself for a moment, Miss East demonstrates vividly that a young woman of her time was marriageable at the age of fifteen. Her life expectation was less than it is today. She matured more quickly. You may think it unlikely that Sarah reached the age of nineteen to find herself, as did many of her contemporaries, unwanted, neglected, on the shelf.

There is a marked contrast between the first trade label, clearly devised by Isabella unaided, and the second for which she seems to have applied to her husband for help:

> Profiles in Miniature by Mrs Beetham at 2/6d for each and a duplicate gratis, and if not the most taking likeness, no gratuity expected. At 4 Cornhill, Near the Mansion House. Children taken equally perfect. Time of sitting one minute. N.B. Shades of absent or deceased friends accurately reduced to any size and dressed in perfect taste.

It would seem that she was the first to introduce the offer to copy and 'redress in perfect taste' shades of absent or deceased friends which has caused so much puzzlement

among today's collectors. This will be dealt with more fully in the section devoted to John Miers.

By comparison with the twenty-seven years she was to spend at Fleet Street, Isabella's Cornhill tenancy was relatively short. It was long enough, however, for her application to be brought into play once more, and the first tentative experiments in glass portraiture to appear. From now on the Beetham family fortunes began to improve. Isabella had an assured clientele for her profiles; her husband showed himself a man of ingenious invention.

Edward Beetham's first invention is still in use today in small theatres and village halls where curtains and scenery cannot be 'flown'. It is known as the 'tumbler' curtain. If you are an enthusiastic holiday-maker you have probably seen it in action. It rolls up on the lower batten as the curtain rises, and arrives with a satisfying thump on the stage when it falls. Its object, in those days, was to reduce fire risks from footlight candles. It filled a need, but it made no money for Edward. His second invention, which was also concerned with rollers, is also still in use, although it must be admitted to have lost a certain amount of its early popularity. It was the 'Patent Mangle with Rollers', and it made him quite a lot of money. It may seem inconceivable that this simple piece of machinery should be of such recent origin, but so it is. One is tempted to ask, how did they get on without it? With that question comes the full understanding of how great the demand for the new invention must have been, and the radical change it effected in the Beetham fortunes.

In the Victoria and Albert Museum collection is an example of Isabella Beetham's jewellery miniatures. The subject is a beautiful woman with long hair rippling over her shoulders. It is painted on ivory and has the Beetham double curve. The portrait itself is a gem, but the remarkable thing about it is its presentation. Usually the glass covering a miniature is convex. In this case it is concave. This reduces light refraction to a minimum, just as do the concave windows seen in expensive modern shops; the spectator is not aware of glass between himself and the objects displayed. Whether Edward Beetham in the 1780's anticipated this device is a worthwhile speculation. It seems by no means unlikely, for at that time his interest was concentrated on the subject of glass. He undertook a journey to Venice to investigate a new method of gilding glass, the better to set off the beauties of his wife's portraiture. Glass painting was a chief preoccupation for both of them.

Isabella took a course of lessons from the miniaturist John Smart mainly for the beneficial effect it might have on that branch of profilism. She had little desire to paint coloured miniatures. Smart left the country in 1784 to practise for several years in India, and by the time he went the new method of portraiture had been safely launched [54].

Edward Beetham, with money flowing in from the patent mangle, bought the lease of 27 Fleet Street. The lower floors were occupied by the business of selling the new

C. John Buncombe of Newport, Isle of Wight. An officer of the 89th Regiment. 8 in. x 6½ in. (Page 68).

machine, an enterprise which demanded ever more space. To satisfy the demand it eventually became necessary to lease No. 26, next door. Isabella had a fine studio on the fourth floor and an assistant, William Gardiner, to help her. In his autobiography, Gardiner claims a considerable share of the credit for her success. It is a claim for which his previous experience as a scene painter would hardly seem to have qualified him.

By the time of their removal to Fleet Street the Beethams had two daughters, Cecilia, the elder, and Jane, who was to make her mark as a profilist. She was not yet in her teens but was soon to start learning the technicalities of painting on convex glass, filling with wax or making composition backings. Her name appears on what was probably the last trade label issued at Fleet Street. By comparison with Isabella's first and second labels her third, issued on arrival at Fleet Street, is positively laconic.

Profiles by Mrs Beetham, No. 27, Fleet St.

Her fourth, three years later, is minimally more relaxed. Like its predecessor it leaves the impression that Mrs Beetham is too well known to need a fanfare:

Profiles in Miniature by Mrs Beetham,
27 Fleet St., 1785.

The inclusion of the date 1785 started a hare which continues to run today. By that year the popularity of the new 'portraits on chrystal' was firmly established. They were in steady demand and this label therefore has had a much wider circulation than its predecessors. In consequence, some of the early collectors, finding themselves the possessors of some of these dated labels but without examples of earlier ones, jumped to the false conclusion that 1785 was the year of Isabella's removal to Fleet Street. In spite of researches by Mrs Nevill Jackson which have brought to light the circumstances of Edward Beetham's purchase of the lease, the idea still claims its adherents.

The fifth and last label which announces (without any flourish of trumpets) Jane Beetham's participation in her mother's affairs, is slightly more amiable:

Profile Likenesses by Mrs and Miss Beetham,
No. 27, Fleet St., London, finished in a most
beautiful and slight manner on Crystal, Ivory
and Paper. Time of sitting, one minute. Price
2s 6d to 2 guineas. Old shades reduced and dressed
in the present fashion.

The date at which this label was issued is uncertain.

Jane married a lawyer, John Read, at some time previous to John Opie's divorce in 1795. In 1794 she began her series of Royal Academy exhibits. She retained her maiden name as a 'nom de peintre', however. It appears in the Academy catalogues until in 1808

she removed an 'E' and became Jane Betham. The Fleet Street period lasted for twenty-seven years. In 1809 Edward Beetham died and Isabella closed the studio. In 1815 Jane Beetham opened her own studio in Lamb's Conduit Street, and showed that she could produce work equal in quality to that of her mother in a highly individual style which owed nothing to any other profilist, and which, once seen, could not be confused with that of anyone else. She did not use Read as a professional name until she had this studio. An outline of her career will be found under that name.

Isabella's professional career lasted for thirty-five years, only five years short of Miers's. His great characteristic was his reliability. He had a standard. It was never abandoned. Isabella Beetham was by no means as reliable, but for that reason she can be more interesting. She is capable of surprises. For me, her best work gives the lady pride of place.

5. Sarah Harrington CUT BP ITIN

Whether the profilist used a machine or not, and whatever the kind of machine used, the quality of the portrait depended entirely upon the ability of the person who did the final painting or cutting. Of the truth of this there can be no better demonstration than the third and fourth of our five ladies, Mrs Harrington and her partner Mrs Collins.

Mrs Harrington was the first professional operator known to use a machine. She not only used it, she invented and took out royal letters patent for it. Having done so she advertised that she 'took the most Striking Likenesses . . . by Virtue of His Majesty's Royal Letters Patent granted to MRS HARRINGTON by the King for her Improved and Expeditious Method', thus creating the impression in any simple mind that she had at least received the Order of Merit. There seems no doubt that she was fully entitled to her pride in the patent, which was an imaginative effort for that time. It consisted of a sort of *camera obscura* in which the rays of the sun were allowed to enter through an apperture to cast a shadow. When the sun was not available artificial illumination took its place.

She took out the patent for her machine on the 24th June 1775. The specification states that it was for 'taking likenesses, furniture and decorations, either the internal or external parts of rooms, buildings etc., in miniature'. The person whose likeness was to be taken was seated so as to appear to the best advantage and his profile taken. The articles and furniture surrounding him were taken separately. The results were assembled and composed into a picture. This was then reduced with the aid of a pentagrapher which appears to have been the forerunner of the present-day pantograph. There was no mention of any cutting instrument incorporated in the machine. The picture reduced in size was used as a pilot for scissor-cutting or for brush-work, whichever the profilist preferred.

An error which occurs in Mrs Nevill Jackson's book *Silhouette* (1938), has given rise to a belief that Mrs Harrington worked as a profilist very much earlier than was actually the case. On page 114, writing in connection with her visit to Leeds in 1780 (the one which is considered likely to have influenced John Miers to try his hand as a profilist in the following year), the authoress records a line in her advertisement which runs: 'Royal Letters patent approved. Profilist to the King.' After the word 'King' has been added an explanatory parenthesis '(George II)'. It implies that her Royal appointment was before 1760, and we know this was not the case. The line refers to the granting of her patent, which took place in 1775. Three or four lines further on there is a reference to a likeness inscribed 'Mrs Lythall by Mrs Harrington, 1775. Cut with scissors (Plate 64)'. One turns to plate 64 and there the portrait is given the date 1760. There is no doubt in my mind that the correct date is 1775.

Considering that Mrs Harrington took out her patent in 1775, it might seem probable that she worked as a freehand cutter for a year or so before applying for it. It is equally possible that she was incapable of freehand cutting and depended on her machine for taking an outline, cautiously protecting it by patent before starting work professionally. This is one of the problems I have been aware of for some time. So far no evidence has come my way that Sarah Harrington worked before 1775. Until it does, that is the year in which her career began.

Sarah Harrington was a cutter, and her speciality was the hollow-cut [15]. This means that she cut the portrait out of a sheet of white paper, and placed a sheet of black paper behind the hollow-cut portrait. If you ask why she chose this method when the more straightforward one would seem so much simpler, the answer must come from a study of her results. She had an almost unbelievable delicacy of touch. Cutting is considered the lowest in the scale of methods employed by these artists, while painting on glass or on composition battle for top place; but Mrs Harrington, with her advertised scissors could hold her own with the best. One is sometimes tempted to disbelieve her line about the scissors when confronted with effects which seem impossible to have been achieved with anything but a razor-sharp knife.

Do not think for one moment that she limited herself to the hollow-cut paper portrait. She is not as easy as that. She cut straightforward portraits and she also painted. She did not condescend to paint on anything in general use for the purpose. She painted on silk and satin! One of her hollow-cut portraits (of a provincial lady, *c*. 1787-8) has a stamped *pewter* frame ($5\frac{1}{2} \times 4\frac{1}{2}$in.)—one of the three such frames recorded.

6. Mrs Collins CUT BP ITIN

No sooner was Sarah Harrington granted her patent than Mrs Collins appeared on the scene. She scented success and wanted to form a partnership. Sarah sold her half her patent rights, and engaged her first as pupil and then as assistant. Before very long the

partnership came into being. A very curious arrangement it was. One might reasonably have expected them to set up in business together, probably at Sarah's London studio 'over Mr Henderson's Chymist shop at 131 New Bond Street'. Nothing of the kind. Off they went, each her separate way, paying well-advertised short visits to provincial towns. One wonders whether they ever held a board meeting.

However, more important than their financial arrangements is the quality of their work. They used identical methods and one might expect a similarity in results. On the contrary. While Mrs Harrington combines sophistication with a flowing line, Mrs Collins's work seems at best experimental. It was not for want of encouragement. A noble sitter at that time in our history was a spur to achievement. Then look at the portrait of the Duchess of Newcastle in the Victoria and Albert Museum, wrongly attributed to Mrs Harrington [14]. Can anyone doubt that this backward effort was perpetrated by poor Mrs Collins? Since the attribution of authorship is a matter of importance to collectors there is a further reference to these two ladies to be found in the section devoted to John Miers. A portrait is discussed which bears his unbroken label, and is clearly a copy of another artist's work.

On the subject of labels it has always appeared a little odd to me that neither Mrs Harrington nor her partner troubled to devise one. The explanation might be that in those early days they had not encountered a label of one of their few competitors. Sarah Harrington seems to have enjoyed writing her advertisements. One would think she might have spread herself (and her patent) on a label. Mrs Collins made no appreciable effort to impose her personality on the partnership, and it would appear that they both traded under the Harrington name and the patent aura.

7. Mrs Lane Kelfe
<div align="right">G PC BP ITIN JM</div>

The work of this artist is rare, and of a rare beauty [16]. As a general rule Mrs Kelfe painted on paper or card likenesses whose faces were painted in black, while their dresses were shaded in detail. She advertised profiles on glass, satin and enamel, shaded and plain, and stressed her exhibition of no less than one hundred and sixty different examples at her apartments, No. 20, Duke Street, St James's. She was 'from Bath' and in every respect an itinerant profilist.

There are no traces of her profiles on glass, satin and enamel nor of her 'miniatures to be worn in watches!' Wellings at about the same time was offering 'faux-montres'. In either case these seem to have been a species of locket, enclosed and disguised, to ensure reticence in respect of the person whose profile was being worn.

Mrs Kelfe seems to be the 'odd one out' of our five ladies: to influence and be influenced by none of them. And this is odd, for Mrs Collins, too, came from Bath. She, too, had apartments in Duke Street, St James's, and was in every respect an itinerant profilist. If ever they met they kept very quiet about it.

THE CONVERSATION PIECE

8. William Wellings PC BP FL CON JM
 and
9. Francis Torond PC BP FL CON

At this point in time two male competitors for honours in their own particular fields arrived whose names, Francis Torond and William Wellings, were destined to become linked in the minds of today's students of their art owing to a similarity in aims and quality. Working on a larger scale than their competitors, they were distinguished by the grace, the elegance and the good breeding they depicted of the age in which they lived.

Torond was a drawing master. Torond was not his real name, which is lost to us, but one assumed for the purposes of his profession, for he was a refugee from France of Huguenot descent. Early in 1780 he removed from Bath to London, where he was first established at 3 Prince's Street, Leicester Fields, and subsequently removed to Wells Street, Oxford Street. His pupils were 'carefully instructed in the use of Indian Inks, Chalks and Water Colours, and in drawing from Models or from Nature'.

In like manner Wellings's interests were not solely confined to the painting of profiles. He took up his residence at 3 Tavistock Row in 1778. In 1792 he removed to 16 Henrietta Street, Covent Garden, at which time, like many another portraitist he turned a natural taste for the theatre to his professional advantage.

A few years earlier John Miers had advertised his portraits of Sarah Siddons, with that august actress's permission, for sale to the public. The offer had met with a success of which Wellings must have been aware. He was acquainted with John Philip Kemble, and had been responsible for designing dresses in the theatre. In 1793 we find him publishing stiple engravings by F. Warburton of his own portraits of Johnstone as 'Murtock Delaney' in *The Irishmen in London* and Kemble as 'Octavian' in Coleman's *The Mountaineers*. The latter, a stipple in colour, was sufficiently popular to merit reprinting in 1797. In the 1794 exhibition at the Royal Academy, he showed a 'Portrait of a lady of quality' and a painting depicting Kemble and Mrs Siddons as Cromwell and Queen Catherine in Henry VIII. His advertisements at that period include a notice that those 'wishing to obtain portraits of the Performers at either of the Theatres Royal, may have them in any character requested on a few days notice'.

As profilists both these artists proclaimed their willingness to execute bust size or full-length portraits. It is for the latter [17, 20], and for their inimitable conversation pieces [18, 19] that they are most admired. At that time the full-length and the conversation in profile were something of a novelty, and on them Torond and Wellings thrived and founded their reputations. The innovation brought them esteem in the eyes of their

45

contemporaries. In ours the details of dress and glimpses of domestic interiors lend their work an added interest.

The earliest attempt to provide the sitter with a milieu, to bring him down, as it were, from Olympian heights and emphasize his earthly existence, were made by Joliffe with his simple device of the draped curtain. Torond and Wellings (and particularly the former) took this up and carried it gracefully forward. It was, on occasion, used with superb effect, and happy the players whose setting is as tastefully draped as that of the lady illustrated in Torond's single-figure composition [17].

Comparison of their work frequently brings the comment that Torond was the better 'traditional' portraitist, since he worked frequently in black and white without variation of half-tones. His single figure composition, here illustrated, chances to conform to standards which were introduced by a later artist, Augustin Edouart. It is balanced without unnecessary embellishment, and typical of the rhythmic symmetry inseparable from his work. The softness required for harmony in the design, together with the suggestion of light and colour, are admirably conveyed without tonal variation.

The portrait of a beau by Wellings is an example of a different and possibly easier method [20]. It is dated 1783, and it was some nine years later that the artist announced that he was 'the Original Person that introduced the so much approved and admired Light Shades in the Profiles, thereby giving them an Elegance of Appearance, and expressing the Drapery and the Dress in a style peculiar to himself alone'. Here then are the approved light shades, and it must be admitted that they do very much what Wellings claimed for them, for what could be more elegant of appearance than his beau, and how could one better express the drapery and the dress?

Occasionally Wellings did thus stress the artificial languors of the time, and make them mildly amusing to the eyes of our matter-of-fact age. His portrait of William Pitt, however, taken at the age of twenty-one to commemorate his famous speech in favour of the American colonies, is a model for the presentation of statesmanlike deportment. Nevertheless, there is a frequent insistence on the sitter's superiority to such a flattering degree that one cannot doubt that he 'had the honour and the happiness to meet with the approbation and patronage of the first personages and judges in the three Kingdoms during the fourteen years of his residence at Mrs Sledges in the above Street'.

That the description 'conversation piece' may sometimes prove misleading is shown in one of the examples by Torond which we illustrate, where there is no attempt on the part of either artist or sitters to suggest a lack of continuity in the air of friendly under-standing silence [19]. The result is a delicious study of the masterful and the demure. It is a Bath newspaper which engages the gentleman's attention, and behind the frame is the trade label of Ricards, the Bath picture-framer, together with Torond's London direction written in a contemporary hand. It seems probable, therefore, that the painting was done immediately before Torond's removal to the capital.

Studying their work, what impressions do we gather of the men? Is Wellings hovering

in the background, delighted with the approbation and patronage, smiling, bowing, slightly subservient? Is Torond, though a modest fellow as his restrained announcements show, unconcerned by the importance of his patrons and wholly interested in their complete suitability for the exercise of his own form of pictorial delicacy? Or are they equally concerned to present their sitters among graceful furniture, fragile porcelain and tapering candelabra, weaving a pattern of which the keynote is a vivid presentation of manners in their stylized age? However this may be, they were two elegant exponents of their art whose work, while rarely encountered today, generously repays attention, for they left a legacy of beauty small but valuable, and executed (in Torond's words) 'in the genteelest possible taste'. It may be a comment on our own deterioration that 'genteel' is now associated with 'shabby'.

10. William Hamlet G BP FL ITIN

For many years this artist was known only by his work and his surname. His portraits of army officers in dashing uniforms, full lengths admirably painted on glass and frequently enriched with gold leaf and his equestrian portraits of George III in all his regal dignity were magnificent additions to any collection [21]. One felt that there he was, a ghostly figure in the background, the artist enjoying the vaguest Shakespearian connotations.

Then a trade label appeared which gave the Christian name he had hitherto so successfully concealed. William! 'Bill' Hamlet!! The glamour vanished as one read.

There was a further blow to come. Industrious research disclosed that there was not one Hamlet but two! The first was born in 1779 and died in 1815. He was not a stranger to us for Mrs Nevill Jackson had recorded him. But when he was six years old, that is to say in 1785, another William Hamlet advertised in Oxford and also in Birmingham that he was a visiting profilist, and claimed to be 'at the height of his powers'. The relationship between the two Hamlets was puzzling and so was the dissimilarity in their work. One was so very much better than the other.

Then a portrait appeared of Viscountess Melville. It was by the inferior painter and bore the authentic 17 Union Passage, Bath, label. Nothing less than a father-and-son relationship could have permitted the use of the Hamlet studio and label for a work such as this. The William Hamlet (1779–1815) whom we had been crediting with the fine work for the past thirty years was the son, the inferior painter. The father 'at the height of his powers in 1785' should have received all the admiration.

11. Walter Jorden G BP FL
and
12. Richard Jorden G PC BP FL CON

In 1780 Walter Jorden, a painter on flat glass [23], whose confidence is exhibited in every line of his work, and his brother Richard who painted with equal skill both on glass and

paper and card [22a, b] made their appearance. There is no evidence whatever beyond a study of their work which prompts me to assert with confidence that neither of them used a 'machine' nor had need of any mechanical aid whatever. Unfortunately the boldness evidenced by their painting is counterbalanced by the paucity of information to be found about them.

Walter Jorden has an individual style of painting lace by which his work may be identified with certainty. This may be studied in our illustration. There is a fine full-length portrait by him at Windsor Castle, long thought to be Queen Charlotte, but more recently attributed convincingly to Madame de Genlis. She is shown admonishing her pet dog. The fact that he was commissioned to paint this refutes any suggestion of his obscurity, yet apart from their work nothing is known of either brother. Neither had a trade label. Neither issued an advertisement. There is not even a known address at which they may have lived or worked.

However, since the above was written, the Royal conversation piece which we reproduce has come to light [22a]. It shows Richard as a glass painter of quality equal to his brother, but diametrically opposed in feeling. Walter was gay, Richard stern. Hence the popularity of the former.

13. John Miers COMP BP ITIN JM

By comparison with the Jorden brothers, the career of John Miers from the day in March 1781 when he set up in business at the sign of the Golden Oil Tarr in Lowerhead Row, Leeds, until the day of his death in June 1821 is an open book. He was born in 1757 at Quarry Hill, Leeds, the son of John Miers and his wife Sarah. The family is believed to have descended from the seventeenth-century Dutch painter Frans van Mieris. Miers's father was a coach painter whose work included the production of heraldic panels. The son seemed destined to follow in his footsteps.

In January 1781, aged twenty-four, Miers married Sarah Rothery. In March of that year he bought the business of a Mrs Walker in Lowerhead Row and advertised that he would sell by wholesale or retail 'all sorts of Paint &c which he is determined to prepare in the best manner'. He would carry on the business in all its branches and would deal in artist's materials. As an afterthought he had a house to let, and there was a distinct hint that he would do any decorating that might be required. Everything ran on the lines laid down by destiny. And then, in a timid little postscript, he went off the rails:

> 'N.B. Profile Shades in Miniature. Striking
> Likenesses drawn and framed at 2/6 each.'

The modest afterthought is said to have been prompted by a visit to Leeds paid by Sarah Harrington in 1780. The theory seems most feasible. Whether it is true or not, John Miers could not have had the slightest inkling of the effect of that short announce-

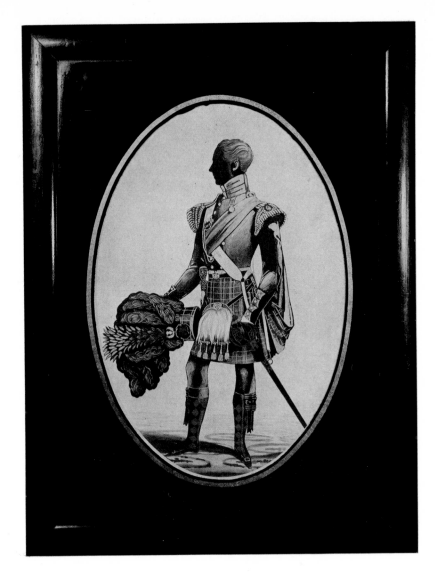

D. Frederick Frith. An officer. An aspect of his
work in direct opposition to his 'Girl with a
basket of flowers'. $14\frac{1}{2}$ in. x 11 in. (Pages 73–4).

ment. It was to revolutionize the sort of life he might have expected. His first trade label was reprinted three times in the remaining nine months of 1781. At the first reprinting there was an increase in the price. Subsequently the question of price was ignored. The painting and gilding, the artists' materials, the picture frames and the houses to let went overboard. In so short a time was the profilist born and launched on what was to prove the finest part of a fine career.

The first years of any business must be a proving time; a time for finding mistakes and rectifying them. The first mistake that Miers made was to use a frame made of plaster of Paris for his portraits. Clearly he must have regarded the whole thing as an ephemeral experiment; something to give a momentary pleasure like a sideshow at a fair. His clients quickly disabused him of this idea. Frames which had suffered a little hard treatment were returned. He took the hint, and before the first year had expired a stamped brass frame in the identical design of its predecessor appeared and remained in use to the end of the Leeds period. Next he had some trouble with a medium which he employed to enhance transparencies. It was found to discolour with the action of light and was abandoned.

Miers's portraits during the first year, while desirable collector's acquisitions from the standpoint of rarity, show him in some respects undecided: he is making up his mind in matters of style and proportion, and settling points which, once ruled on, would remain as standard throughout his career. Once he had these matters under control his confidence became evident. By the end of the year 1782 a gallery of men in wigs and ruffles, together with lovely women in waving plumes and floating transparencies, materialized. They seemed to have painted themselves and carried the painter with them [25].

There is no reason to doubt that Miers was the originator of the method of painting shades on a composition of plaster of Paris. The 1780's produced a number of artists who favoured this method and used it well. But until he appeared on the scene the black-and-white portrait on paper or card had had but one variation, the painting on glass. Now glass preserves an unbending attitude towards paint and a Walter Jorden or an Isabella Beetham is required to coax it into flexibility, whereas composition receives paint lovingly and admits variations of tone and shade comparable to soft-paste porcelain. Shades painted in this way had the immediate appeal of novelty and Miers soon found himself hard pressed with work and in need of assistants.

He could not follow the present-day pattern and advertise for them. How were they found? It seems that there must have existed some equivalent of what we now call the 'grapevine' for he certainly received three applications and possibly more. The three accepted were Houghton, Thomason and Mrs Lightfoot. Whether J. Smith of Edinburgh became a pupil of his at Leeds is not definitely known, but he must be accepted as a member of the 'Miers school'.

By 1785 Mrs Lightfoot had left him to set up for herself in Liverpool. In the same year Houghton departed to form a partnership with George Bruce, and instruct him in

the Miers method. Thomason probably remained until Miers moved to London, and in 1790 he settled in Dublin, continuing to order his trade labels from Shillito, the Leeds printer who engraved Miers's sixth and seventh Leeds labels.

The five names just mentioned form the nucleus of what we now know as the Miers School. The two remaining members of the school were Thomas Lovell, who is thought to have joined him in 1789 and who established his own business in Bread Street, Cheapside, in 1806, and John Field who came to him in 1800.

These are the seven members of the school at present known. Since one of the fascinations of this particular study is that snippets of fresh information appear at unforeseeable intervals, the possibility must not be ruled out that there are others awaiting identification in the future.

It would seem likely that the 'principal profile artist' (to give him the high-sounding title that Field invented in preference to 'assistant') would be entrusted only with tracing an outline, particularly in the early stages of Miers's career. He would then reserve for himself the responsibility for the diaphanous draperies which became the distinguishing feature of the Leeds period. There is no documentary evidence to indicate Miers's procedure and we are forced to rely on inference. Support for the present inference may be found in a comparison of portraits by Miers and Mrs Lightfoot. She was his assistant and it will be seen that she has retained his outline formula, just as she was accustomed to do it under his direction. What has been changed is the style of decorating the outline. Here she has not attempted to copy him but has developed a distinctive style of her own.

This, while supplying a feasible picture of the studio procedure, does nothing towards answering a riddle which has demanded an answer for years. All the seven members of the Miers school are painters. Miers's Original Shades from which the finished portraits were taken were sixteen by twenty inches in size and were cut out from black paper and mounted on card. A specimen may be seen in the Desmond Coke Collection at the Victoria and Albert Museum. The riddle is: who took the cut-outs?

The teething troubles of the Lowerhead Row studio having been overcome by 1783, Miers, in that year, made another step forward. He issued his first announcement of miniature likenesses painted on ivory for setting in rings, pins, lockets and bracelets. This was the first step towards becoming a jeweller in London. The miniature on ivory would be taken by the sitter to a jeweller who would make the necessary piece for its display. Very often the result would be shown to the artist for his approval. There is little doubt that after a number of these inspections Miers decided not to allow his work to be overshadowed by the ornate, or cheapened by the ineffective. As soon as possible he would make his own settings.

His first announcement of these miniatures coincided with another development, his decision to pay visits of limited duration to the principal northern towns. The first to be visited was Newcastle-on-Tyne where the announcement of the ivory miniatures was

made. He returned there in 1784 and also visited Manchester. In 1785 he went to Liverpool and in 1786 to Manchester and Edinburgh. In 1788 he paid a third visit to Newcastle.

In Edinburgh he completed eighteen portraits of one family and its connections. Most of the persons portrayed had played a by no means undistinguished part in the country's affairs. The portraits remained in the family's possession until 1958 when they were offered for sale in London. Before this Miers's profiles of the Leeds period had been seen in salerooms but occasionally and never in quantity. These Edinburgh profiles of the Steuarts of Allanbank were housed, all eighteen, in a cabinet that had probably been their home since the reign of William IV. They looked as if they had but recently left the artist's studio, and made a noticeable impression even on the uninitiated. They included Sir John Steuart, fourth Baronet, and Lady Steuart together with Sir John Coxe Hippisley, who negotiated the marriage of the Princess Royal and Prince Frederick the future King of Würtemberg, and his wife; the fourteenth Earl of Errol and two of his sisters; and Admiral Elliott and Robert Dundas, the future Lord Armiston, who, as President of the Court of Sessions, presided over the hearing of the Douglas succession cause.

One can understand that if these were the kind of people who were flocking to Miers for his services, there was no further reason to wonder at his courage in uprooting himself, a pregnant wife and four young daughters, and leaving Leeds to try his luck in a London he had never previously visited.

The visit to Edinburgh at which the Steuarts of Allanbank were prominent produced another client who was justifiably famous. Sarah Siddons, the great actress of the time, sat to Miers for her portrait [25]. When he solicited her permission to allow him to offer copies for sale to the public, she allowed the instinctive desire for publicity felt by members of her calling to guide her, and graciously gave it. Miers, while unwittingly intruding into what was to be William Wellings territory, had started something which would flower into picture postcards of Gaiety beauties later on. In December 1788 he finally took the plunge and packed himself, his family and their possessions into a coach to set out for the capital.

For what happened on his arrival we have no on-the-spot witness; no testimony but that of the man himself as written in his trade labels. But what a clear story they present, given a little consideration. In his first London label he sets down his name, that he is from Leeds, and gives his Strand address. Then without a word about profiles to hang in frames, which have without exception previously been his first consideration, he rushes straight into an announcement about jewellery pieces on ivory 'to set in Rings, Lockets etc' because he cannot yet provide the jewellery himself. The miniature pieces fill his mind. The first London label remained unchanged for two and a half years.

The second London label comprises no more than six words: 'Miers (Late of Leeds) III Strand.' His first London address, 162 Strand, was perhaps unsuitable for the

developments he had in mind. So he announced his removal in the rarest of his fourteen labels. So rare it is that very few people have seen it. Why? It can only be because it was so quickly superseded.

In the third London label we are given the key to the enigma, again in the first few words, 'Miers, Profile Painter and *Jeweller*.' It is clear that this is what has obsessed him for so long. He has at last got the jewellery department started.

He is not yet the maestro who can refuse to take a portrait for which someone else will provide the brooch or the locket (as witness the old phrase 'for *setting in* Rings etc') but that will follow before long, and the tell-tale phrase be dropped in subsequent labels.

The appearance of the third London label coincided with what is called 'Miers best frame' on which it is usually found. This is slightly larger than the average papier mâché frame, the brass inset has gone and is replaced with a chaste ornamental moulding. It surrounds a fine convex glass decorated with a broad gold band, set between narrow black lines.

The third London label, together with the 'best frame', made their appearance in 1791 and by that time the phrases in his label indicating that he kept Original Shades, could supply copies at any time, and would copy shades made by other hands and 'dress them in the present taste' had been freely copied by his competitors.

Plagiarism of other people's labels was constant, naïve and shameless. No sooner did one profilist have a good idea than all the others followed. These copies still exist; the incidence of their appearance is rare but, for the advanced collector, their identification is one of the major excitements of the chase. He must be sufficiently acquainted with the work of the principal artists to identify them by their style before confirming his opinion by label or signature. Further he should have all the indications which are essential for fixing a reliable date for a portrait at his fingertips. Thus equipped he may (though not very frequently) detect a likeness as having been copied from another artist unknown, or even more rarely from one who can be identified. His chances of attributing a portrait 'redressed' are negligible, unless by some minor miracle the original is available for comparison.

The work of John Miers and of his successors, the firm of Miers and Field, offers the best opportunities for success. Miers in his forty years of profilism issued no less than fourteen trade labels and the partnership two more, and these are of great assistance in assessing approximate dates. In addition, apart from some slight modification on his arrival in London, a modest restraint on the élan of his Leeds work, his style remained so consistent throughout his career that the slightest variation is immediately suspect.

The partnership of William Miers and John Field which succeeded John Miers at his death in 1821 must have derived no inconsiderable part of its income from copies, most of which were made from earlier portraits made by the great man. A typical specimen of this work, a likeness of a man wearing a tied wig and painted in the bold proportions of the

52

Leeds period, but bronzed and having the papier mâché frame and label of the partnership, has recently come to light.

Three examples of Miers's work are shown here. The one in the stamped brass frame demonstrates the fine proportions of his work [25]. It was once in the possession of Desmond Coke, and then passed to the collection of Mrs Nevill Jackson, who identified it as a likeness of Sarah Siddons. It was probably one of those sold to the public with her permission.

The second portrait of a lady by Miers is an example which immediately arouses suspicion of being a copy from a likeness by another hand [26]. It is painted on composition, enclosed in a papier mâché frame, and bears Miers's fourth London label unbroken. Allowing the widest possible limitations of date, every factor points to it having been produced between 1801 and 1818. Yet the headdress worn by the lady and the piled hair-style beneath it suggest a fashionable sitter of an earlier decade, probably of the early 1780's.

Had this been a copy from one of Miers's Leeds portraits, the curve by which it is cut off at the base would have been much more bold and ample, while a momentary study of his method in relation to the generous handling of transparencies affords convincing proof that he was not the original painter of this somewhat drooping drapery. Reference to the portrait of Mrs Siddons will confirm these points. In this case the attribution to an earlier artist can be made with reasonable certainty. The static quality of the headdress suggests that the original may have been in cut paper, and this narrows the field. Isabella Beetham, Sarah Harrington and her partner Mrs Collins are all known to have done cut-paper likenesses at the time, but Isabella Beetham may be ruled out immediately for there are no points of resemblance. Sarah Harrington is much the more likely candidate. The curve which cuts off the base and denies authorship to Miers is exactly what we should expect from her. The transparency in her original rendering was, of course, opaque. The bow of ribbon at the nape of the sitter's neck is an additional pointer, for this seems to have been a finishing touch which Mrs Harrington liked to add, probably without regard to whether the subject actually wore it. It is, in fact, a secondary signature frequently found in her work.

Of course we must consider the possibility that the original was by Mrs Collins, Sarah Harrington's pupil and later her partner. These two women used identical methods but comparison of their work reveals a notable difference in achievement. If Mrs Collins were responsible for the original portrait in this case, it would seem that the compact finish of outline in the copy owes a great deal more to Miers than that faint compromise between two styles which is self-evident. Further, the ribbon bow was a personal idiosyncrasy for which Mrs Collins did not seem to share her partner's fondness.

The wording of Miers's fourteen labels, together with two for the partnership of William Miers and John Field follow, together with the dates at which they came into use estimated as nearly as possible.

MIERS TRADE LABELS:

I Leeds Period

No.	Issued	Wording
1.	1781 *Printed*	J. MIERS Painter & Gilder at the Golden Oil Tarr Lowerhead Sells on the most reasonable terms All Sorts of Oils and Colours &c for Painting Also Oval Picture Frames of various Sizes N.B. Profile Shades in Miniature Striking Likenesses drawn & framed at 2/6 each. LEEDS
2.	1781	*As above but the price was raised to 3/-*
3.	1781	Jno MIERS Lowerhead Row Leeds Takes the most perfect Likeness's in Miniature Profile in one Minute, on an entirely new plan; allow'd Superior to any other; N.B. He keeps the Original Shades of all he takes, therefore any Person may have more Copies by applying as above Persons having Shades by 'em may have 'em reduc'd to any size & dressed in the present taste
4.	1781	*Wording as the third label as far as* Persons having Shades by 'em *Then insert :* of living or deceased Friends.
5.	1783 *Engraved*	Perfect Likenesses in miniature Profile, taken by

54

J. MIERS LEEDS and reduced on
a plan entirely new which preserves
the most exact Symmetry and ani-
mated expression of the Features, much
Superior to any other method. Time
of Sitting one minute. N.B. He keeps
the Original Shades and can supply
those he has once taken with any
number of Copies. Those who have
shades by them, may have them
reduced to any Size, and dress'd
in the present Taste.

6. 1783
 Printed

J. MIERS
MINIATURE PROFILE PAINTER
LEEDS

Takes the most perfect likenesses either to hang in
frames, or upon ivory, for rings, pins, lockets,
bracelets, &c.
N.B. He preserves the original shades, and can
supply those he has once taken with any number of
duplicates; or those who have shades by them, may
have them copied, the likeness preserved, and
dressed in the present taste, by applying as above.

7. 1784/5
 Engraved,
 known as
 the Travel-
 ling Label.

*Wording as that of No. 5, surrounded by
an additional sentence,* Orders at any time
addressed to him at Leeds in Yorkshire will be
punctually despatched.

II LONDON PERIOD

Miers moved to London in December 1788.

1. 1788

*The following label was in use from 1788/9 to
May 1791.*

MIERS
(Late of Leeds)
No. 162 opposite the New Church, Strand,
London.
Executes Profiles on Ivory to set in Rings,

Lockets, Bracelets etc, in a peculiar style,
whereby the most forcible animation is
preserved in an astonishing manner.
NB. He keeps all the original shades & can
supply those he has once taken with any
number of copies.

2. 1791 MIERS
 (Late of Leeds)
 111, Strand.

3. 1791 MIERS
 Burnished PROFILE PAINTER & JEWELLER
 Gold No. 111, opposite Exeter Change
 Label Strand, LONDON.
Continues to execute Likenesses in Profile
Shade in a style peculiarly Striking and elegant
whereby the most forcible animation is retained
in the minute size for setting in Rings,
 Lockets, Bracelets etc.
NB. Mr Miers preserves all the Original
Sketches so that those who have once sat to
him may be supplied with any number of Copies
without the trouble of sitting again.
Flat or Convex Glasses with Burnished Gold
Borders to any dimensions for Prints, Drawings &c

4. 1801 MIERS
 Double PROFILE PAINTER & JEWELLER
 Letter 111, STRAND LONDON
 Label opposite Exeter Change
Executes Likenesses in Profile in a style of
superior excellence with unequalled accuracy
which convey the most forcible expression &
animated Character even in the very minute size
for Rings, Broaches, Lockets &c &c.
 Time of sitting 3 minutes.
Mr Miers preserves all the original sketches
from which he can at any time supply Copies
without the trouble of sitting again.
NB. Miniature Frames & Convex Glasses Wholesale
 & Retail.

5.	c. 1812 *Seal* *Engraver* *Label*	MIERS 111, STRAND, LONDON. (opposite Exeter Change) Profile Painter, Jeweller, Seal Engraver and Manufacturer of Frames and Cases for Miniatures Continues to execute the long approved Profile Likenesses in a superior style of elegance and with that UNEQUALLED degree of accuracy as to retain the most animated resemblance and Character, even in the minute sizes of Rings, Brooches, Lockets &c Time of sitting not exceeding five minutes. Mr Miers preserves all the Original Shades by which he can at any period furnish copies without THE NECESSITY OF SITTING AGAIN.

The fifth London label, known as the seal engraver label was in use until Miers's death in 1821, when it was succeeded by the partnership label of William Miers and John Field. There are in addition two labels for jewellery pieces which may be found in small cases. Their wording is as follows:

III JEWELLERY LABELS

1.	1791	Opposite Exeter Change ——————— MIERS Profile Painter and Jeweller. No. 111, Strand. Manufacturer of every description of miniature frames and cases. LONDON.
2.	c. 1800	Opposite Exeter Change MIERS Profile Painter and

JEWELLER
No 111 Strand
Miniatures set and
Framed Hair work
&c executed
peculiarly
neat.

IV Partnership Label

1821

Miers & Field.
111, Strand, London.
opposite Exeter Change
Profile Painters, Jewellers, Seal Engravers
and Manufacturers of every description of
Miniature Frames, Cases etc.
Continue to execute their long approved Profile
Likenesses in a superior style of elegance
and with that unequalled degree of accuracy
as to retain the most animated resemblance
even in the minute sizes of Rings, Brooches,
Lockets &c. (Time of Sitting not exceeding
five minutes).
Messrs Miers & Field preserve all the
ORIGINAL SHADES by which they can at any
period furnish COPIES WITHOUT THE NECESSITY
OF SITTING AGAIN.

V Partnership Jewellery Label

1821

Opposite
Exeter Change

MIERS & FIELD.
Profile Painters
and
Jewellers
No 111 Strand
Manufacturers
of every description
of miniature frames
and cases.
LONDON.

The names under which the third, fourth and fifth London labels are known were coined by L. Morgan May, an authority on the profilist, and a comparison of them with the labels will soon show they are apt. They are an excellent 'aide memoire' and for that reason have been included.

The 'seal engraver' label appeared when Miers started to produce handsome gold fob-seals in which were concealed miniature portraits on ivory. They are extremely rare, and such examples as have come my way have been decorated with the very fine bronzing associated with John Field who had joined Miers at the turn of the century.

There is one thing about these secret seals which may be found puzzling. A seal is essentially a piece of male decoration. (Of course ladies have worn them on bracelets for years. It is quite noticeable!) In a masculine toy with a hidden portrait might not one expect the subject to be a beautiful woman? Whatever one might expect, the subject never is! It is always a slightly unprepossessing man! [60]

While we are discussing Miers rarities, here is another, rarer even than the secret seal because it is unique. I saw it during the 'thirties, and what follows is therefore open to correction.

It has been established that Miers specialized in the bust-size portrait, whether on composition, paper, card or ivory. There is, however, one full-length likeness painted by him, 'The man at the sundial.' I believe it is painted on card, and is in a 'best frame' with the burnished gold label. It was in a private collection where I trust it still remains. There was no indication of who the sitter was; no hint of why the artist departed for once from a settled practice of forty years. It is, of course, just possible that this may chance to meet the eye of someone who has this information. In that unlikely event I should be most grateful if he would pass it on to me.

We are reaching the end of John Miers's career. He has come a long way from the Golden Oil Tarr, and the Striking Likenesses at two shillings and sixpence each. A little account for family portraiture in the neighbourhood of seventy pounds is no unusual thing now; he has a long list of noble sitters from King George III downwards. He is no longer obsessed by plans for jewellery miniatures. What concerns him now is the fear that the organization he has built up, with all it has to offer of the subsidiary adjuncts of profilism, the frames, the hair-work, the patch-boxes and the convex glasses with their burnished gold borders will be allowed to disappear through neglect, and the name of Miers will be seen no longer in the Strand.

It should be clear that he was a man of considerable foresight, and in this matter of the continuity of name it did not desert him. Four years before he died (that is to say in 1817) his son William, who must have been in his late twenties, joined his father at 111 Strand. What discussions, what inducements, what blandishments brought him there it would be interesting to know. Suffice it to say that he came, and was thereby enabled to serve a sort of apprenticeship to the craft. The name adorning the premises was changed to Miers & Son, but no new trade label was issued.

59

John Miers's will, made in the year before he died, made clear the nature of his final obsession, and his solution for the problem, a partnership between his son William and his assistant, John Field. His testament offered every inducement for this to take place. That was how he wanted it. That was how it was done.

14. John Patey COMP BP ITIN

The collecting of profile miniatures dates from the beginning of the present century. By the time the 'great disorganization' came in September 1939 the artists dealt with here had been discovered and recorded with one exception. That exception was John Patey.

Patey's work came to the collector's attention after the war, in the late 1940's. As a result rather less is known of him than of most of the others. He described himself as 'from London' and was clearly an itinerant. His outline was firm and he used a semi-Beetham bust-line which was more nearly a treble than a double curve. In fact he was sensitive to curves, and would not use a straight line if a curve would do. The number of examples I have been favoured to see barely reaches double figures, but in two of these there was the very slightest approach to caricature, which gave promise of a highly characteristic treatment. Let us hope that promise will prove to have been justified in future discoveries [29].

15. S. Houghton COMP BP JM

Was this artist fonder of children than, let us say, Isabella Beetham, Sarah Harrington or Mrs Lane Kelfe? Was it for this reason that he made something of a speciality of child portraiture? For without doubt he did, and his studies of children show a delicacy of perception quite astonishing when one remembers what uncivilized little brutes they can be.

Whether or not he had experience as a profilist before joining Miers at Leeds is uncertain. He left Miers in 1785 to instruct George Bruce, with whom he subsequently formed a partnership, and since Bruce's work thereafter approximated more nearly to Miers's than did Houghton's, there is a slight probability that he had. His label, on a portrait of a child painted on composition and dated 1785, begins with an announcement of 'portraits *to set in* Jewellery pieces'. Miers had been producing such portraits since September 1783. Houghton may well have gained some experience of the work in Leeds.

Plates 30a, b show two jewellery lockets painted by Houghton in 1785 and now in the collection at the Victoria and Albert Museum. The subjects are Elizabeth Steuart (aged twelve) and brother James (aged nine). Since this is the least common spelling of the name, they may have been members of the family of Steuarts of Allanbank who were painted by Miers.

16. J. Thomason G COMP BP

As an assistant to Miers at Leeds he learnt the technique of painting bust-portraits on plaster, and eventually arrived at such a level of competence that his work might be mistaken for his master's. Soon after Miers left for London he decided to settle in Dublin [28].

Thomason went to Ireland in 1790 and stayed in Dublin for three years. In the following May his advertisements directed towards residents in the surrounding countryside propounded an ingenious 'do-it-yourself!' scheme of profilism. He suggested that 'any number of ladies and gentlemen, not less than three' should apply for his instructions on taking an outline, and that they should send the results to him to be finished. He assured them that mistakes would be rectified. He guaranteed satisfaction. As an idea to save travelling for both sitter and profilist this might appear commendable. However, there is no record of its success, which would seem to have been negligible since the scheme never reached this country.

He continued to paint portraits on composition on the lines laid down by Miers. In addition he took to painting on glass likenesses which he backed with wax. It is a curious thing that in this latter work the change of medium appeared to release him from any obligation to Miers's instruction, and these portraits show no trace of Miers whatever.

17. Mrs Lightfoot COMP BP ITIN

This was the lady who was John Miers's assistant in the early days at Leeds. She left him in 1785 to set up on her own account at Liverpool.

In the actual taking of the profile she followed the Miers method strictly, only varying it by the use of a denser black. There can hardly be any doubt that here she repeated the work to which she became accustomed at Leeds. Her own ideas were brought into play when it came to the final decorating of the portrait. The Miers transparencies are gone and embellishments of an entirely different nature have taken their place. There is a panache in Miers's treatment which is lacking in Mrs Lightfoot's, but nevertheless it is good to see that she is no mere copyist. Not content to be a 'poor man's Miers' she emerges as an artist in her own right [31].

A suggestion has been put forward that her personal character was not of the brightest. At this late date, this is of no importance. Her work puts her in the front rank, and it is all we need to judge.

18. A. Charles COMP PC BP CON JM

It was Charles's habit to sign his work 'by Charles R.A.'. His trade label announces that he painted conversations, but I must admit to never having seen one. The label is rare and

signatures are by no means common; collectors should pay attention to his treatment of hair which is distinctive, and also his signature which has a recognizable idiosyncrasy.

Charles is said to have been a poor miniaturist, and while this may be so he was, without doubt, a very fine profilist. It is his distinction that he did not use a machine and employed no artificial aid of any kind. He drew straight from the human face, boasting that he could take the outline in three minutes, and finish the likeness in one hour [32].

His advertisements were more bombastic than the most optimistic of his competitors, and his constant description of himself as a 'Royal Acadamean' has led more than one authority to take him at face value, and accept that he had some right to assume the title. In fact he had none if we are to believe the Royal Academy on whose behalf it is stated that 'Charles was never a student, associate or exhibitor'.

Nevertheless he was commissioned to paint a likeness of Queen Charlotte which may be seen in the Royal Collection at Windsor, and was appointed Likeness Painter to H.R.H. the Prince of Wales. He was, of course, a showman by nature which does not deny his right to be an artist by nature too. It is, all too frequently, a confirmation.

19. H. Redhead G BP

This artist, who is not known as an itinerant, advertised from an address in Upper Norton Street, Fitzroy Square, London. He produced work of distinguished quality, but could hardly have been prolific. I have seen four or five examples by Joliffe and six or seven by Charles for every one by Redhead. His painting on glass brings to mind the work of Lea of Portsmouth. This does not mean that he stippled faces and portrayed features and expression as Lea did. On the contrary he painted faces dense black, and used stipple with considerable effect in the decoration and the dress [33].

20. J. Smith COMP BP JM

Smith's address was North Bridge Street, Edinburgh. He described himself as a 'Hair and Pearl Worker' so his experience must certainly have included the sentimental arrangement familiar to us on the reverse side of expensive lockets, a ringlet of the beloved's hair held captive by a ringlet of pearls.

A glance at his work as a profilist ensures instant recognition of him as a member of the Miers school (see p. 49). What is more it shows him a faithful copyist of his master. He did not, as did Mrs Lightfoot, attempt to stamp his own individuality on a likeness. He was content that it should resemble both the sitter and what Miers would have made of him as closely as possible. With this in mind he succeeded, and there is little doubt that the Leeds formula took its familiar course and paid off financially [34].

J. Smith and Thomason probably replaced Houghton and Mrs Lightfoot as assistants

to Miers in 1785, and served him until he left for London in 1788. Thomason was soon afterwards established in Dublin, and Smith in Edinburgh where, in that year, he was advertising in the *Caledonian Mercury*.

21. Carl Christian Rosenberg

G COL BP FL
GRO JM GILDING

Rosenberg was born in 1745 and died in 1844. He is said to have been born in Hanover, and to have come to England as a boy to be page to Queen Charlotte. Later he was King's Messenger to both George III and George IV. Under George III he was His Majesty's Profile Painter. Since he wore the Windsor uniform and was continuously engaged at court, he had unique opportunities for royal portraiture which he was by no means backward in taking. He has left a large gallery of likenesses of George III's numerous family, together with records of meetings between the monarch, Pitt and Fox, which are often highly amusing [37].

He lived to the age of ninety-nine, and was in his forties before he took up profilism. When he did so he made Bath his headquarters. He is known to have worked at three addresses there, and to have enjoyed a great part of the patronage competed for eagerly by a large number of talented artists who had settled in the town [36].

As Torond and Wellings are linked in the minds of collectors by a similarity of aims and quality, as Lea and Buncombe share a similar fate by portraying one the navy and the other the army, so Rosenberg and Foster spring jointly to the mind in their capacity to survive to a remarkable age in the not always calm atmosphere of the royal court.

22. Edward Ward Foster

PC CUT COL BP

A native of Derby and the son of wealthy parents, Foster started life with considerable advantages. An army commission was purchased for him, and in due course he appeared at court. He had obtained some mastery of the art of profilism with the aid of a machine, and had cultivated an individual, if variable style. The greater part of his work he painted in Venetian red and decorated with bronzing, frequently in a trefoil pattern. Likenesses of this kind now and then suffer the mild disfigurement of a black tie or ribbon. He would very occasionally paint in blue-grey dotted with white to replace the bronzing, and such portraits are wholly delightful [35].

Foster was appointed miniature painter to Queen Charlotte and Princess Amelia and must have had opportunities for royal portraiture comparable to those enjoyed by Rosenberg. However, for whatever the reason, he has not left a comparable gallery of portraits. The invalid Princess died in 1810 and when the Queen also died in 1818 Foster returned to Derby, sharing his working life between that city and his London address, 125 Strand. He lived to the age of one hundred and four, had several wives, and

63

there was a gap between the ages of his eldest daughter and his youngest of sixty-eight years.

23. W. J. Phelps G COMP PC CUT COL

At some time during the 1830's a profilist, who had arrived here from France to honour us with his presence, decided that it was high time that somebody (and by somebody he meant himself) formulated strict rules governing what should, and should not, be permissible in this kind of portraiture. It must be in black and white only. No decoration within the face or figure would be countenanced. Nothing was 'correct' which lessened the force of contrast. He was patronizing about what had hitherto been achieved, but let it be known that he was taking the matter in hand, and would 'raise this form of portraiture to an art'. As a preliminary he proceeded out-of-hand to re-christen it, a procedure which did not arouse the acclaim which he expected.

Despite this setback Augustin Edouart's rules were reverently received; in fact they were swallowed whole, for we were not so far from the eighteenth century for credulity to have wholly disappeared. This would not perhaps have mattered had the new rules been applied solely to himself and his successors, but they were not. Both the new name and the new rules were applied haphazardly to what had been done in the previous half-century by artists who were precluded from knowledge of him or them.

In addition his new rules were nonsense! They were made by a man who argued that if what he did was right for himself it must be right for everybody else. Since this was his sincere conviction, his opinions were delivered with an authority which lent them all the force of the Mosaic law. Many more people believe them today than disbelieve, and some of our finest profilists have had strictures laid on them that they could not possibly deserve. Let us take the case of W. J. Phelps, who had more than one method. He had a masterly touch with the black and white portrait on composition in which field there were so many competitors. Here he could not be faulted [B]. But his other method (cry shame on him) was unique and therefore beyond competition. It consisted of a curious combination of cutting and painting which produced the most attractive results. He cut the portrait out of buff-coloured paper which he then pasted on white card. He painted in the hair, and added a touch of colour to the dress, leaving the underlying buff colour for the men's frilled cravats and the women's laces. The colours he used were a rich blue, apple-green, lavender and a brilliant primrose. The amount of effect that he managed to cram into these small likenesses with the minimum of effort is quite remarkable [H].

Now see how the forceful opinions of Edouart have persisted into our own time. That well-established authority, Mrs Nevill Jackson, for whose opinions I have the greatest possible respect writes, 'The three portraits I possess by Phelps in colour are, I think, the most beautiful among the thousands in my cabinets,' and then she bows the knee to the great Edouart and continues, 'although not the most correct for shadow portraits

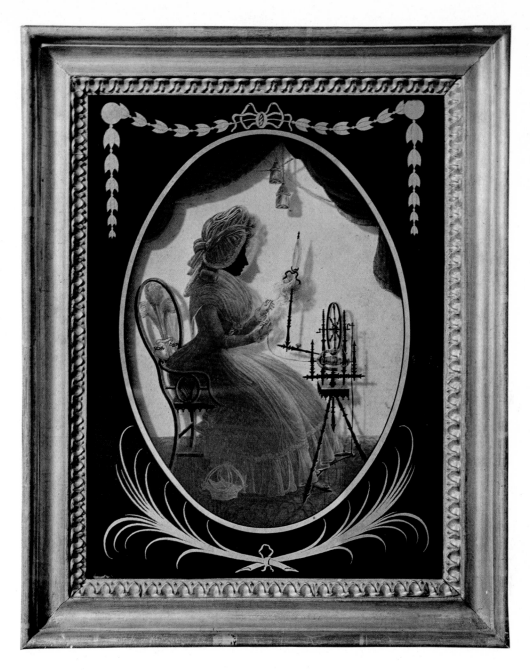

E. Jane Betham (Mrs. John Read), daughter of
Isabella Beetham. Mrs. FitzHerbert. One of
the notable discoveries of recent times. $18\frac{1}{2}$ in.
x 10 in., centre oval $8\frac{1}{2}$ in. x 6 in. (Page 82).

should be black only.' There is nothing more to be said—except that the man who made that law eventually failed to keep it himself [38].

24. T. Rider G BP JM VERRE ÉGLOMISÉ

Although this artist presented himself usually as T. Rider, but occasionally as L. T. Rider, there was no corresponding variation in the quality of his work; nothing to lead to the suspicion that here were two different men. He had one notable distinction. He was the only British professional profilist of the eighteenth and early nineteenth centuries who used the *verre églomisé* method in his portraiture [frontispiece].

In this method the likeness was painted on the underside of glass, and backed with gold leaf. It would seem that the technique came into existence with the early Christian churches. One of its practitioners in the 1760's who gained some renown for his results was a Frenchman, Jean-Baptiste Glomi. His name, pared to essentials, survives in that of the method, which was much practised among continental artists. Although many of them emigrated and settled here, none brought the method with him, and it was left to Rider to practise it.

There has recently come into my possession a fine example of his work which bears the label containing what one might judge to be the first announcement of his adoption of this method [41]. It runs as follows:

LIKENESSES

taken in miniature Profile and finished in a rich and curious Stile on Enamel, *also on Glass with a Gold Ground*, in a manner entirely new. Coats of Arms, Crests, Cyphers, Writing or any Device, wrought in Gold on Glass.

Persons having Likenesses in Shade of their deceased Friends, may have them reduced or copied and emblematically represented in a curious manner.

Large shades reduced within the compass to be worn in a Ring, Pin, Locket or Bracelet, on Enamel, Ivory or Paper, and the Likeness carefully preserved and dressed in the present Taste by

T. RIDER, Profilist,
No 3, Charles St, Covent Garden.

N.B. He preserves the Originals and can supply those he has once taken with any number of duplicates.

Here, once again emphasized, is the precept that the first paragraph of a trade label contains the key to what was uppermost in the mind of its writer. Rider shows himself highly aware of the possibilities of *verre églomisé* for portraiture and heraldry. He does not use that term, which had probably not come his way, but there is no doubt about what he is describing.

In a label which may be thought to be somewhat earlier than the foregoing, and which

E

Mrs Nevill Jackson dates as of 1789, he claims to have invented gold bordered glass, but since Isabella Beetham was using something very similar in 1782, it would seem to be a claim difficult to substantiate. That label runs as follows:

RIDER.

Profilist.

Inventor of Gold Borders on Convex Glasses which gives a Painting, Print or Drawing the effect of the finest Enamel. Any Lady or Gentleman in the Country by taking their own Shades may have them reduced from 2s 6d to 1£ 1s. Particularly in his new manner for Rings on Crystal which have the effect of the finest topazes. Time of sitting, one minute. At MR BILLINGTON'S, Print Seller, Temple Bar.

It was at one time thought that in the partnership with Bazing which was formed ten years later (see Appendix, p. 117) the *églomisé* portraits were introduced by the latter. The newly discovered label shows that this was not the case. They were already in existence. Evidence has yet to come my way that Bazing was himself a profilist. Until it does I shall continue to believe that he filled some other role in the partnership.

The portrait of a lady which forms our frontispiece may have an attraction for those interested in feminine modes. The fashion for decorating with ostrich feathers the more formal hats worn by women came into being in the early 1780's. At that time the fashion plate was not yet in existence, a decade was to elapse before it was born. Until that happened, and indeed for many years afterwards, the creation of a new fashion was a matter conducted deliberately and with a curious slowness. When eventually launched it might take twenty years longer to reach the country cousin than it would to be adopted by her relative in town. Once created it could be equally slow to pass away; which amid today's immediacy of communication is difficult to appreciate.

This particular fashion, however, was launched most auspiciously. Thomas Gainsborough painted his portraits of the Duchess of Devonshire, and they were exhibited at the Royal Academy between 1780 and 1784. They were a popular conversational topic, not only in fashionable London, where their impact was immediate, but in such parts of the provinces as were artist-conscious and received them at leisure. The 'Gainsborough hat' became a description so universally known that a section of the public believed the hat to be the artist's own creation. Few could resist its appeal, and in consequence the fashion continued to exist in recurring phases of popularity, lasting into the early years of our own century.

It will be noticed that Rider speaks of portraits 'on Enamel'. Mrs Lane Kelfe was another who advertised work in this medium. One can only echo the despairing cry of Desmond Coke when writing about her in his *Confessions*. 'Where are all the specimens by this artist on enamel?' Coke had never seen one by Mrs Kelfe. I have never seen one by Rider—or by Mrs Kelfe either come to that! You, of course, may be more fortunate.

66

25. George Bruce COMP BP JM

Legend has it that Bruce and Houghton were old acquaintances before the latter visited Leeds and became first a pupil and afterwards an assistant to John Miers. In 1785 Houghton left Miers and shortly afterwards returned to Edinburgh, where Bruce was in business as a jeweller and framemaker in South Bridge Street.

When the two men met, Houghton was full of enthusiasm for profilism and the success Miers had achieved by its means in Leeds. Bruce, with whom business was not encouraging, became interested in another's success story and pressed for details. The upshot of the matter was that Houghton agreed to instruct him in Miers's methods of taking shades. He proved a promising pupil, and after his period of instruction he set up in practice by himself. His work, curiously enough, bore a closer resemblance to Miers's than did Houghton's, and he had considerable local success. Among the portraits he took, one dated 1789 has come to light, and one of Robert Burns now hangs in the National Portrait Gallery in Edinburgh [40].

Bruce's work was becoming known and there were ample clients to keep two people busy. A partnership with Houghton was preferable to taking a pupil who would eventually leave and set up on his own in opposition, and for that reason the partnership of Houghton and Bruce came into being in 1792 using the latter's premises for its headquarters.

The new firm issued an engraved label worded as follows:

PROFILE SHADES
executed in a
peculiar style whereby the
likeness is admirably preserved and
reduced so small as to set in Rings, Pins,
Bracelets, Lockets &c by

HOUGHTON & BRUCE.

The original draughts are preserved
therefore any number of copies can be
furnished to their employers.
Any having shades by them may
have them copied or reduced the
Likeness preserved and
dressed in the
MODERN TASTE.

South Bridge St., Edinburgh.

67

26. Mrs Bull PC BP

Little is known of this lady, since she refused to sign, had no trade label, and did not advertise. In fact she could only have increased her anonymity by taking the veil! This was extremely irritating of her because her work was so delightful that it deserves a signature. She should have been proud of it [43].

How to recognize it? You see a portrait which looks exactly like the work of Charles. You take a hard second look and think, 'he's taken much more care over the hair than he usually does.'

That one is by Mrs Bull.

27. John Buncombe PC COL BP

The military painter of the Isle of Wight, whose male sitters (and he made less than half a dozen portraits of women in all probability) wore military uniform exclusively [C], is still at the centre of an unsolved riddle which has exercised collectors since the early years of this century: Was he a professional or a gifted amateur?

There are those who believe he was an amateur because none of the habitual accompaniments of the professional have been found. The name of John Buncombe has not figured in any advertisement of his time, neither has it appeared on any trade label. He did not hand over his portraits 'framed complete' as did most professionals. They were usually painted on card and given to the sitter for him to take away and frame. As a result a large proportion of them found a home in scrap-books. Where there is a trace of that uniformity so dear to the professional profilist, it has been achieved by collectors who have rescued these gems from imprisonment in scrap-books and put them on show in frames of the period. No one could seriously advance the argument that John Buncombe's work was amateurish [42, C].

If you wish to think of him as a professional nothing is easier than to find answers to the foregoing objections. The importance of the infantry depot was such that at any given time a great number of officers were at liberty with time on their hands, anxious for some distraction where distractions of any kind were few. They would need no advertisement to find their way to Buncombe, a dozen of their fellows could tell them where he lived. His clientele, while consisting largely of officers, did not exclude 'other ranks'. Had he been a gifted amateur this would hardly have been the case, for he would have belonged to one social class or the other. Many of his clients would have likenesses taken for relatives or even prospective relatives (who could resist the temptation, when wearing a glamorous uniform, to put one's appearance on record?) and would prefer to send them unencumbered by a frame.

In any case, as far as this artist is concerned, whether he was an amateur or a professional is of little importance. What is important is the varied gallery of insolent military

giants he left behind to regale us. He recorded the gold and scarlet panoply of military splendour in such fine detail that, with but a little attention, we may hear ghostly drums and bugles in the background [39].

Apart from the importance of his work to military historians and those interested in the records of regimental crests and numbers, it has a general appeal exceeding that of other artists. Their merits are appreciated mainly by connoisseurs. The evidence for his greater popularity may be found in the modern prints, based on his portraits, which hang in art shops far and wide and produce twittering encomiums from interior decorators.

28. Lea

<div align="right">G BP STIPPLED FACES</div>

Lea was the naval painter of Portsmouth; his male sitters (he made probably as few portraits of women as did John Buncombe) wore naval uniform exclusively, or otherwise were clearly naval officers in civilian clothes.

He painted on convex glass in pale stipple of fine quality. Unlike his military counterpart at Newport, he concentrated his stipple on his sitters' faces, painting their features and expressions with meticulous attention to detail. Behind each portrait he placed a composition backing, and the finished likeness was enclosed in a plain papier mâché frame of better-than-average manufacture but with no brass inset or other decoration to relieve it. Grudgingly he permitted himself three chaste gold rings to adorn the edge of the portrait glass. Accuracy, observation and restraint combined to produce profile miniatures surrounded by an air of integrity appropriate to the service from which his clientele was drawn. There is no ostentation, no *Rule Britannia* and barely the faint echo of a bosun's pipe is evoked, but we recognize a master of his medium [46].

29. John Field

<div align="right">PC COMP BP FL JM</div>

An examination of the documentary evidence leads inevitably to the conclusion that John Field joined Miers as Principal Profile Artist (his own description) or as Assistant (Miers's word) in the year 1800. In the same year he exhibited a landscape at the Royal Academy. He was twenty-nine years of age and a trained artist.

It has long been accepted that he was responsible for the marked change in fashion experienced by Miers's portraiture: that is to say in the gilding or 'bronzing' of the profiles, both those to hang in frames and the jewellery miniatures. There is no doubt whatever that it was he who did this work, for there were few who could bear comparison with him, and certainly none who did it better. There is little doubt that Miers, always prepared for a change, felt that with the advent of the new century a certain re-shaping of the exhibits on display was required to mark it, and for that reason engaged Field, who probably suggested the way it could be achieved [45].

Field continued to exhibit at the Academy, but it was not until the year 1804 that he sent in his first landscape painted on the composition with which he became familiar by his work in the profilist's studio. It was speedily followed by others, and how delicate these small landscapes are [59]. Why, one wonders, do not more artists use composition?

Although Field became a regular exhibitor at the Royal Academy he continued to derive his income from John Miers at 111 Strand, which was the address from which he sent in. His life there progressed without major change until the year 1817 when William Miers joined the firm as a student of its affairs. But what was he there to study? He had a considerable choice: frame-making, seal engraving, jewellery manufacture, and glasses with burnished gold borders and the various processes of profilism. There was talk of a partnership in the air and he had to make up his mind. There is no written evidence, but it seems likely that he left the profilism entirely to Field who was so good at it, and concentrated on the administration of the other branches. This theory is supported by the fact that, at the end of the partnership in 1831, Field set up on his own account and was, with very little delay, appointed profilist to Queen Adelaide. He was still advertising in 1840. William Miers continued as a frame-maker until 1835 and then faded quietly out of the picture.

Gradually, as the partnership settled into a groove, the work of John Field deteriorated for the lack of his old employer's supervision. The deterioration was not enough to be a set-back to the business done by the partners. Probably it was not noticed by their clientele. But if any one doubts that this was the case he has only to examine the jewellery pieces in the Victoria and Albert Museum collection. They are not on public display, since they were removed to safety during the second world war, and have not since been restored to a gallery. They may be seen by application to the Department of Prints and Drawings on the first floor. Here they are kept in cases which will be brought for your inspection.

Compare the lockets and brooches bearing the tiny faint signature 'Miers' with those signed 'Miers & Field'. The heads in the former are relatively small and neat, and the features pin-point sharp. Those in the latter are slightly larger and by comparison almost clumsy. The contrast provides convincing evidence of the excellence of Miers's control. Field never quite regained the high standard he had attained in the first two decades of the century. Even the tonic of a royal appointment, not only to Queen Adelaide but to H.R.H. Princess Augusta, failed to extract that little extra in his work which he could always give after a few words from Miers.

Field had experienced thirty settled years at 111 Strand; to change his address three or four times in the next ten must have made him feel that he was itinerating!

30. W. Rought G BP GRO

An excellent painter on the underside of convex glass. Since he practised in the Corn-market at Oxford, a proportion of his sitters wore cap and gown. There is an example, a portrait of an undergraduate, painted on glass and backed with card, which may be seen in the collection at the Victoria and Albert Museum [44].

A much more ambitious example of Rought's work, consisting of a group of nine persons, is in the Royal Collection at Windsor Castle. It depicts George III, Queen Charlotte and their six daughters, with a footman carrying parasols in attendance. This is an 'all-in-one-line' group, the King facing to right, Queen Charlotte and the remaining personae facing him to left.

There is a startling uniformity in the dress of the royal ladies. Seven stubby little decorations resembling oversized shaving brushes stand erect above seven crushed-in top-hats. Only three parasols are in use. The remainder are under the footman's arm. Dresses and faces alike are painted in deepest black. The only concession to detail is in a few deft touches with the white brush to indicate light falling on a glossy surface.

31. Henry Hervé G COMP PC CUT BP JM

We first hear of Henry Hervé in the year 1801, the year following that in which John Field joined Miers. This is the very slightest of coincidences. Field joined Miers and the character of the profiles emerging from 111 Strand was completely changed by Field's 'bronzing'. It was a facet of the art in which he was pre-eminent. Yet if anyone could have challenged Field's mastery it was Henry Hervé. It would need a very ex-perienced connoisseur to distinguish between a portrait bronzed by Field and one by Hervé without assistance of signature or label [47].

This, of course, applies to his jewellery miniatures, and to his bust-size portraits on composition. Hervé was a versatile fellow and he had a scale of charges for every pocket. For half-a-crown and five minutes of your time you got a paper cut-out. Miniatures were 'from one guinea *upwards*'.

He makes great play in his advertisements with his use of 'Hawkins Patent Machine' by means of which 'Complete Satisfaction is Guaranteed'. The plain fact of the matter was that he stood in no need of a machine or any artificial aid whatever. He was a fully trained artist and exhibited at the Royal Academy for several years in succession. But he knew, as some of his competitors knew, that a machine was a talking point among his clients. Many of them would boast of the splendid qualities of Hawkins' Patent and remained unimpressed by the abilities of Monsieur Hervé. So if they wanted Hawkins' Patent, bless their little hearts, they should have it. He would make sure it didn't spoil his work.

32 Thomas Lovell
COMP BP JM

Lovell is generally accepted as having been Field's predecessor at 111 Strand, and by 1806 he had established himself at 32 Bread Street, Cheapside. He painted on composition in the Miers manner without bronzing or other interior decoration of the portrait, nor with any attempt at the gallantry of transparencies. Nonetheless, it is difficult to distinguish between his work and that of Miers in his early London manner [48, 49].

33. Hintor Gibbs
G (WAX FILLING)
PC COL BP

Hintor Gibbs served for upwards of twenty years in the Bedfordshire Militia, attaining the rank of corporal, and, while his tally of military likenesses is negligible, he apparently managed to combine professional profilism with his military duties for several years before his demobilization in 1815 [50].

While capable of very good work, a noticeably large proportion of his portraits on convex glass are uninviting because of his reliance on wax as a backing. While wax may make an acceptable background to a likeness fresh from the studio, it does not stand up well to the rigours of time. It discolours, it cracks, and as it deteriorates so does the likeness. This seems to apply particularly to Gibbs's work. Perhaps the good corporal used tallow? Whatever the reason it is a pity. Gibbs could use colour in his work with excellent effect.

Another curious thing about him is that although his record of military portraits is almost nil, he was nonetheless commissioned to do a portrait of Queen Charlotte. He took a very uncompromising view of her ugliness. He made no attempt at palliation.

34. T. London
BP ON IVORY

London's address is given as 26 Cross, Worcester; he is of comparatively recent discovery, being unknown to such early collectors as Wellesley or Sutcliffe-Smith. He was strictly a one-method man since he did not paint on composition or glass; neither did he have any truck with jewellery miniatures. Mr London of Worcester painted bust-size portraits of the usual two and a half by three and a half inch dimensions and he painted them very well. He chose to paint them on ivory, which makes him singular, almost unique! [51]

35. Mrs John Read (Jane Beetham or Betham)
G AQUATINTA LIKENESSES

In the year before Isabella Beetham moved from Cornhill, that is to say in the year 1781, a young man, heralded as a 'natural untutored genius' whose work was 'like Caravaggio— but finer' was presented for the admiration of London's art-lovers. He was aged twenty, he came from Cornwall, and his name was John Opie.

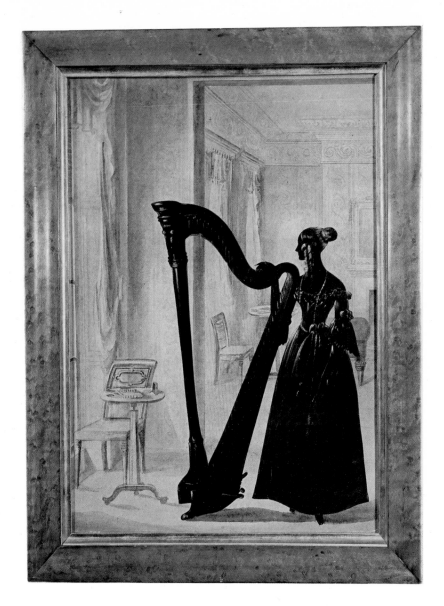

F. Charles Hervé. 'The girl with the harp'. The
subject is cut, lightly bronzed, and laid on a
painted background. $18\frac{1}{4}$ in. x $13\frac{1}{2}$ in. (Page
113).

Immediately he set about justifying the reputation which had preceded him, and was soon generally known as the 'Cornish Wonder'. He was made a Royal Academician at the age of twenty-six, and would have been very little to our purpose but for the fact that he fell in love with Isabella Beetham's daughter Jane. Unfortunately he didn't do it as promptly as he might have. He waited several years, and during those years he married someone else. So when he realized that he was in love with Jane, he set about divorcing his wife, an expensive and protracted business in those days. He managed it, however, just in time for Jane's wedding to a wealthy lawyer many years her senior.

By that marriage Jane Beetham became Mrs John Read, the name by which she is known to us as a portraitist of outstanding ability and highly individual style. If Mr John Read the lawyer had any professional connection with the Cornish Wonder's divorce suit, the facts have been discreetly concealed, which is just too bad. They might have rounded off a humdrum little story very nicely!

But what could not be concealed, what shone out like a good deed in a naughty world, was the influence her tardy-cum-precipitate lover brought to bear on Jane's work. For him she was a serious artist, not merely the little-known daughter of a famous mother, giving a helping hand at the Fleet Street studio. And as is so often the way with women, what he thought she was, that she would be. In the year 1794 she exhibited for the first time at the Royal Academy. She sent in from the Fleet Street address, and modestly confined herself to three works. They were all accepted. 'Eloisa', 'Andromeda' and 'Judith'. In 1795 she showed a 'King Lear and Cordelia', and she did not stop there. She declared for portrait and miniature painting, and in a period of twenty-two years from 1794 to 1816 she showed in thirteen Academies.

By this time, her mother having closed the Fleet Street studio and retired, Jane Read had opened her own studio at 72 Lamb's Conduit Street. There, while still pursuing the technicalities of glass painting, she made a complete break with the styles made so popular at Fleet Street. She was still as good, but she was completely different. It was a difference that her clientele appreciated. She delighted them with the semi-classical poses she favoured, the pastoral backgrounds she preferred, the stone pedestals and bronze urns with which she surrounded them [52, 53].

The influence of Opie pervaded the studio. He was not there in person, for he died in 1807 leaving her sad little love story incomplete. But his aura was everywhere at Lamb's Conduit Street. Even on her trade label there was his description which could apply to either of them, Portrait and Historical Painter. (See also pp. 37–42 and 80–83.)

36. Frederick Frith PC CUT BRO COL BP FL

Strictly speaking Frith should be described as a nineteenth-century cutter, but to speak as strictly as that would be to do him a considerable injustice. It is true that the first stage of his technique entailed the cutting of the figure, but it is in the subsequent embellish-

73

ment of that first stage that the hand of the artist becomes apparent. For the second stage of Frith's method involved the finest brushwork. He used colour of contrasting brilliance, and rounded off his work without ever overstepping the bounds of restraint [D].

He started as a youthful prodigy, and while he advertised that he would take bust-size portraits he had a personal preference for full-lengths, a preference which he seems to have communicated without much difficulty to his prospective sitters if we may judge by what predominates among the specimens available today. His military subjects may well be looked on as 'full-length Buncombes'. In quieter mood, as in the 'Girl with the basket of flowers', he pioneers with that most noticeable Victorian quality, charm [55].

5. The Question of Attribution

In the early days of collecting the neophyte who finds an experienced enthusiast prepared to help him with instruction and advice will do well to accept the offer with proper expressions of gratitude. In its essence collecting is a competitive enterprise, and with that fact in mind it is a trifle surprising that beginners should receive this kind of help as often as they do.

The mentor will probably be the owner, if not of a fully representative collection, at least of some worthwhile specimens. The opportunity of handling and subjecting them to close examination will prove invaluable in clearing the way for his pupil to become a qualified collector. This implies one who is prepared to buy a profile miniature without label or signature for one of two reasons, because he appreciates its fine quality or because he has instantly attributed it to a particular artist.

Let us deal with the second reason first. Attribution is never a matter of attaching a random name to a portrait. You are not a collector unless you are prepared to show your purchases to fellow enthusiasts, who will be quick to detect faulty attributions.

As for the first reason for buying, appreciation, this takes courage and a considerable amount of self-confidence, the more particularly when the dealer, whose training has made him quick to detect high quality in whatever it is he is selling, matches it with an equally high price. You may be able to attribute it later, after more careful study and reflection. You may never be able to attribute it at all. In that case are you going to live happily with it on your walls, or will you grow to hate the sight of it? It is for you to decide, and sometimes your decision must be made in a hurry. This sort of contretemps happens when you are killing a short wait between trains in a strange town. A famous collector once said, 'In all my years of collecting, the only things I regret are those I didn't buy.' To avoid such regrets it is incumbent on the collector to become qualified by an intensive study of the characteristics of these artists, continued until his speed of attribution reaches its possible maximum. Why should he take the trouble?

There are two main reasons. First, while most of the artists with whom we are concerned were brilliant creators of small things of beauty, at one and the same time their crass stupidity in not recognizing that this was beauty which would last, allied to their unbelievable laziness in failing to attach a signature or label makes one despair of them. Second, the unimaginative placing of cleanliness before godliness which led intervening owners to destroy as unimportant such labels as artists *had* troubled to affix

in order to remove a few specks of dust. Such people would polish vintage wine-bottles!

The collector who declines portraits by Sarah Harrington, the Jorden brothers, Joliffe, Buncombe, Redhead, Lea or Mrs Bull on the ground that he will wait until he is offered signed or labelled specimens, is going to wait a very long time, during which his collection is going to look painfully thin. Study characteristics and buy when you are confident.

If friends tell you that it is impossible to get together a representative collection today, don't let that deter you. Of course it isn't as easy as it was forty years ago, but it is still quite possible. It is largely a matter of how much remains in what dealers call the 'lock-up'. By this they mean genuine antique pieces which remain in private ownership until death or the disintegration of a family bring them into the open market. The 'lock-up' in the case of profile miniatures is no Mother Hubbard's cupboard, and seems unlikely to be for many years to come. For what emerges from it there are no factual statistics, but from personal observation it would seem that for every desirable specimen identifiable by an artist's signature or label, at least three others appear with neither. Happily they seldom defy attribution.

How to begin studying? Suit yourself. You may already have a penchant for some particular artist. Make yourself familiar with his or her work until you detect some feature or other recurring again and again. Then find another whose methods are somewhat similar. Study similarities and differences until you are confident that you can identify them with no possibility of confusion. You may find yourself up against a blank wall at first, but don't let that discourage you. Everyone else has experienced that, why shouldn't you? You will see daylight eventually.

And when you begin to get a little confidence and want something really difficult, take on the Miers school. There are eight of them, including Miers himself. Six of them served him as assistants, and learned from him direct. The seventh, George Bruce, learned from him through the good offices of Houghton, and acquired a greater resemblance to Miers's own results than did Houghton himself. See what similarities and differences you can distinguish here. Miers made rules which they all obeyed, more or less, regarding the curve which finished the lower part of the bust, and its relation to the upper part of the head. It is in the treatment of hair that differences occur.

Mention of hair brings Charles to the forefront of the mind. He had a method of painting hair which, while most effective, took the minimum of time to execute. Compare him with Mrs Bull who seems to have taken longer. Decide which you prefer.

It is all very well for me to recommend airily that you should do these things. For all I know you may not have acquired the mentor mentioned earlier. In that case there is no national collection available for you to visit, where you can be sure of finding the major profilists represented. The Victoria and Albert Museum can show you about half of them, but this is no special credit to them since they were enabled to do so by a bequest made to them by Desmond Coke in the early 'thirties. The collection has been

out of the public view since the outbreak of the second world war. If you wish to see it you must make application to the Department of Prints and Drawings. Not only has it been out of view, but no single addition has been made to it out of museum funds since it was acquired. The only addition since that time was donated. It is German.

Of course, if you can afford to fly fairly frequently to America you will have less difficulty. The art of the profilist has gained a greater following there. In this country, which took the lead in its encouragement as a professional art and brought it to a higher artistic level than did any continental country, it has been, until recently, much more taken for granted.

It may be from this that its neglect by the museum authorities springs. It can hardly be that they think it of too little importance for them to take trouble. One does not wish to exaggerate its importance which, after all, is a matter of opinion rather than fact. As a subject for a collection I should put it somewhere below old master drawings, and a comparable distance above postage stamps. If you collect old master drawings I should expect you to agree with me. If you are a postage stamp man I should not.

It is not my intention to quote prices anywhere in this book. As dwellers in the Age of Fluctuation we all realize that yesterday's prices are as out-of-date as yesterday's newspaper. But it is nonetheless proper to mention that prices for profile miniatures have moved upwards in accordance with those for old master drawings, and even those for postage stamps. We collectors are not poor relations.

The only remaining recommendation for the collecting beginner, and one which will help him with current prices and instant attributions, is to keep an inquiring eye on our leading sale-rooms. He should attend on viewing days, decide which, if any, of the lots he would wish to acquire and how much he is prepared to pay for them, and attend again on the day of the sale to confirm or revise his decisions. By doing this he will not only increase his knowledge of the subject; with a minimum of luck he will make contact with others who are interested in it too. Such contacts are invaluable in bringing life-blood to a hobby which, without them, is a lone-wolf occupation.

The subject of *églomisé* profilism has not received any attention so far, probably because it was much more practised in continental countries than here. It is, as mentioned in the account of T. Rider on page 65, a method of painting in black on the back of flat glass and subsequently covering the glass with gold leaf. Occasionally the process is reversed and the drawing is in gold with a black backing.

A little, a very little, English *églomisé* was produced in the eighteenth and early nineteenth centuries and should a worthwhile piece ever come your way, count yourself extremely lucky. Don't refuse it! No one would wish you a lasting regret such as mine in connection with the names of Rider and Bazing.

There are two examples of *églomisé* recorded in which the subjects are English, as is one of the artists, but neither artist, as far as can be ascertained, was a professional portraitist whose services were available to members of the public.

The first is by M. R. Prosser and may be seen in the Victoria and Albert Museum Collection. It is done in the *églomisé* process reversed and shows George III and Queen Charlotte crowned with laurels, in gold on a black ground. No other work by M. R. Prosser is known.

The second was recorded by its then owner, Mrs Nevill Jackson, in her book *Silhouette*. It is, she says, 'a fine family group in *églomisé*'. There are three figures in a handsomely furnished room: a seated lady and two children. They are named Jeanne, Countess of Harrington, Lord Viscount Petersham, and the Hon. Lincoln Stanhope. On page 84 in the book the date is given as 1760 and on page 34 as 1795. Considering the vast amount of spade work in recording done by the diligent and tireless Mrs Jackson, there is no occasion for apology for this further discrepancy. The first Lord Petersham was born in 1780 so that the second date is probably correct. The work is signed, the signature being Bouttats. No other work by this signatory is known, and one might surmise that it was painted by a continental artist while on a visit here.

There are certain artists whose work is so entirely characteristic that, once seen and carefully studied, you should be able to recognize it wherever encountered. Joliffe is an excellent example. His painting is always on flat glass, always backed with silk (unless some cleanliness-at-any-price fellow has destroyed it) but the small circles punched in the black border, the tendrils which entwine to connect them with pale gold showing through, and the looped curtain which is nearly always forthcoming proclaim the artist's name.

Incidentally, since it is possibly more important that you should be aware of past mistakes than past successes, one of those mistakes had Joliffe travelling incognito for many years. A portrait of an army officer appeared. The painting technique was unknown and inscribed on the back was the name H. P. Roberts, which was taken to be the name of the profilist. It was not until a likeness painted in a similar technique was discovered in the late 'thirties bearing Joliffe's label, that it was realized that H. P. Roberts was the name of the officer.

W. Spornberg is another of the immediately recognizable fraternity. His Etruscan portraits, with their deep red glow, are of quality varying to an almost unaccountable degree, a variation for which no convincing reason has as yet been advanced. The proportion of completely satisfactory examples is high, and no other artist's work is remotely like his.

Isabella Beetham's portraiture falls into three compartments, cutting, painting on card, and on glass. She was, it seems to me, more successful in portraying women than men. In her early exercises in cutting this is not so apparent, but from the time she took to brushwork in order to vary her offerings at the opening of the first studio at Cornhill, her latent capacity for conveying the essence of soft femininity developed and became marked [54].

In the late Fleet Street period there are signs that Jane Beetham had some influence on

her mother's art. In the portrait shown in plate 54 the painting of the dress is more detailed than was usual in Isabella's early days. The sitter's hair, dress, and lace jabot are all painted in very dark sepia. The sleeve of the right arm has first been given a touch of paler sepia and then lined with the dark brush to produce the effect of flesh showing through the stretched material. The ribbon round the head tied with a bow at the back is lined in black to pick out the pattern of the lace. The spotted ribbon at the waist is black also. The earlier portraits do not seem to have these contrasts of black and sepia which are very effective.

While her work is not immediately recognizable to the same degree as that of Joliffe or Spornberg, the amount of study required to achieve this result should produce no undesirable effects in a student in reasonable health. There are certain mannerisms. For example, the ripple of the skirt as seen in the Cornhill painting of Sarah Anne East [12] is repeated in the Fleet Street glass painting of 'A lady' [54] and is of frequent occurrence in her likenesses of women. It gives an effect of gaiety and sprightliness; there is even a touch of ballet about it. With regard to her painting of hair, it has frequently been said that she painted each hair separately which, of course, she did not, but she managed to create that effect.

Carl Christian Rosenberg, the court painter, demonstrated in his full-length studies and groups that his knowledge of anatomy was something less than that of a trustworthy surgeon. He gave little attention to the details of dress, but on the other hand his court studies, particularly when they recorded meetings between George III, the Prince Regent, Pitt, Fox and others of comparable importance had an undeniable capacity for buttonholing the spectator and making him feel that he was witnessing some very odd goings-on in high places. When you have studied one or two of them this quality will be recognizable. So will the peak in the lower line cutting off his bust portraits (the word peak is used not as in the 'peak of a mountain' but as in the 'peak of a cap') which is one of his characteristics [36, 37].

The virile brushwork of Walter Jorden in his likenesses on flat glass might possibly be confused with that of Jacob Spornberg, the painter of the 'Black Spornbergs'. Fortunately the latter preserved his individuality by painting on slightly convex glass [9]. A further point to distinguish between them in likenesses of women is Jorden's characteristic painting of lace which consists of three 'leaves' in outline, one from the sitter's chin to the bow of ribbon at her breast, a second embracing two-thirds of the lower bust-line, and the third reaching to the base of the neck. A triple line of minute dots runs parallel to this outline and the effect of lace is complete[23].

Edward Ward Foster will give you no trouble in your study of attribution. His warm red-brown profiles competently bronzed, with the bronzing frequently in diaper and trefoil patterns, could possibly be confused with the work of Jeffreson, but the differences between them can soon be established. The most noticeable is the basic colour. Jeffreson's is much less red than Foster's.

THE QUESTION OF ATTRIBUTION

There are collectors, many themselves military men, who specialize in John Buncombe's portraits of military giants, fascinated by his unassailable accuracy in the matter of crests, emblems and other insignia [39, 42]. His work exercises a fascination for the faker also, attracted by his more general popularity and high market value, and while most of these gentry are content with reproducing his work as glass-painting, or over-painting photographs published in magazines, there are some whose work is good enough to make a careful and intensive study of his likenesses, not omitting a detail like the painting of an eyelash, necessary before you buy.

Lea of Portsmouth painted naval officers. While Buncombe's army men seem bursting with life and about to 'plant you a facer' Lea's subjects appear conscious of being commemorated for meritorious service. Nothing is known of Lea, save that he painted these stippled faces on glass surrounded by three chaste gold rings. Nothing is known of his sitters, except in rare cases where some relative or friend has written a name. But you have only to look at one example and you will recognize his work anywhere, even in the very rare instances where the sitter is a woman [46].

The last of our immediately recognizable profilists is Mrs John Read who was born Miss Jane Beetham. In her latter name more will be heard of her shortly, for she may be said to have led a double life between those two names. I have mentioned that as Mrs John Read she opened her studio at 72 Lamb's Conduit Street in about 1815, as nearly as can be estimated, and that six years earlier her mother, Isabella Beetham, had closed the Fleet Street studio in which, during its last years, they had worked together. During the interim Jane, clearly a woman of strong character who wished to be assessed on her personal merits rather than on reflected glory from her famous mother, had developed a style of profilism absolutely different from anything that had been done at Fleet Street, or for that matter anything that was being done by her London competitors.

So that when the Lamb's Conduit Street studio opened the Beetham name was gone, the profile shades had been superseded by aquatinta likenesses, the black faces were no more and Mrs John Read smilingly disclaimed any connection with an earlier and out-of-date establishment. Now, the accent was on pastoral backgrounds or wide open spaces, with stone pedestals and bronze urns in the classical manner. So far none has been discovered in which putti disport themselves or Cupids discharge darts at the sitter, but that may come. Make no mistake, Mrs John Read was an artist of originality in conception and fine quality in execution. She is in the upper bracket in any company [52, 53].

Now let us turn from instant attribution to a case in which the answer was delayed. In 1965 the glass-painting shown in plate E was purchased from a Chelsea dealer. Neither buyer nor seller had any inkling of the painter's identity. They were both fully aware of the painting's quality. The dealer, a man of excellent reputation, reported that when it came into his possession he was told that there had been a companion portrait of the Prince Regent which had been accidentally damaged and in consequence destroyed.

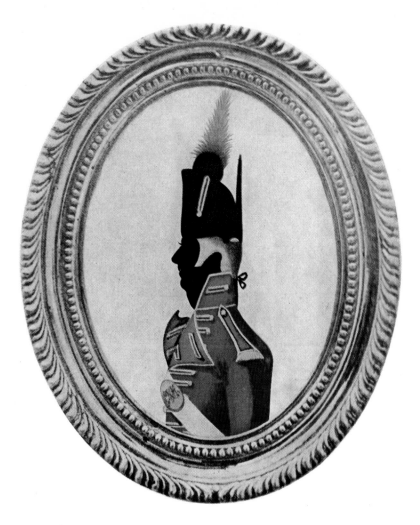

G. Thomas Rowlandson. 'The Lieutenant in
charge of the Tower'. (Page 87).

It will be noted that the Prince of Wales's feathers are prominently carved in the back-splat of the lady's chair. It was thought that the portrait was of Mrs FitzHerbert.

The purchase was completed and the painting went to the Pollak collection, a compilation which has been willed to the Victoria and Albert Museum to supplement the Desmond Coke bequest to representative proportions, subject to a proviso that the museum undertakes its display to the public.

In its new home the portrait was inspected by the members of an embryo collectors' club and voted an important addition. Its size was remarked on as unusual for a portrait of a single sitter. The overall measurement of the frame is twelve and a half by ten inches and the oval in which the portrait is painted is eight and a half by six inches. The decoration of husks and wreaths on the glass surrounding the oval is, like the frame itself, in burnished gold of a superior quality, unaffected by its century and a half of existence. Here you must use your imagination; no photograph can do it justice.

The first step in the inquiry that followed was to test the statement that the sitter was Mrs FitzHerbert. Stories of this kind are common currency in certain antique shops although fortunately not the better ones. The dealer from whom this was bought would not have repeated it unless he had believed it himself, but one should always test.

A spinning wheel, to the modern mind, is associated with cottage industry. Would Mrs FitzHerbert have used one? An examination of her correspondence yielded no applicable reference, but a portrait was found of Princess Augusta engaged in a similar activity, and further inquiry confirmed that the use of the spinning wheel had become fashionable among ladies of social position at that time, and was not thought in the least eccentric. It is clear that the lady under consideration is not the Princess by reason of her age. For various reasons she is not one of the other ladies whose names come to mind in connection with the Regent such as Lady Jersey, Lady Conyngham or Perdita Robinson. Was she Mrs FitzHerbert?

That lady it seemed had sat for her portrait to the leading painters of her day, but very naturally these sittings had taken place when she was in the height of her beauty. She had been painted by Gainsborough, by Cosway and by Romney when she was a young woman. The portrait under discussion was judged to have been painted circa 1810, in which year Mrs FitzHerbert was aged fifty-four. Eventually a water-colour painting of her made a few years later by Lady Blanche Haygarth was discovered which gave some help. The features could be those in our painting. The sitter was wearing an exactly similar dowager's turban and dress. It cannot be pretended that this is conclusive. It would not stand up as identification in a court of law, and a very good thing too. It is the best we can do for the moment, so 'tis enough, 'twill serve.

Now for the question of the painter. The work is of top quality and on glass, so the first thing is to list the names of glass painters who might be working in 1810. There are seven of them, Isabella Beetham, Lea, Hintor Gibbs, Hamlet, Rought, Rosenberg, and Mrs John Read.

THE QUESTION OF ATTRIBUTION

Isabella Beetham was about sixty when this was painted. There is a reminder of her style in that the face is painted in solid colour while the dress is treated in some detail. But she had just closed her studio in consequence of the death of a husband to whom there is every evidence that she was devoted. She was at the end of a career that had been long and frequently arduous. The work had been executed by an equally skilful but younger hand.

One by one the other possibles can be considered and discarded: Lea, a naval painter, not comparable in style and an unlikely choice for such a sitter; Gibbs, the corporal of militia, an even more unlikely choice; Hamlet, more at home with gallant army officers than court ladies; Rought, more at home with academics even though he received a command to paint the King and the royal ladies. The hand that did that painting was not responsible for this one. Rosenberg? Too masculine. Mrs John Read? Too classical.

If you have been studying this book with the care and attention that it deserves you are already in possession of the answer? Yes, you are quite right. It was painted by Miss Jane Beetham or Betham as she was by 1810 [E]. The fact of her use of sepia, an unusual colour for a profilist triggered off a thorough examination of the catalogues of the Royal Academy's Summer Exhibitions from 1794 to 1816. It was found that she showed in thirteen Academies during that time. It was noted that her list of sitters included the Countess of Dysart, the Duchess of St Albans, Lady Wilson, the Right Hon. Lady Falconburgh and the Right Hon. Lady E. Gaman. Just the kind of people, one might think, who could have discussed her work with Mrs FitzHerbert.

Some curious facts emerged as sidelights in this inquiry. They have no significance in regard to our subject matter as far as can be seen at the moment. However, experience shows that unexplained facts sometimes fit into a larger pattern and lead to welcome conclusions. You, my reader, may be the one who needs these small pieces in a jig-saw puzzle. Here they are.

In 1808 Miss Jane Beetham changed her name in the Academy catalogues. She elided an 'e' and became Miss Betham. Subsequently she showed portraits of eight members of the Beetham family. All their names changed to Betham. By itself this would be hardly worth reporting, but it chanced that there was another exhibitor at the Academy, approximately of Jane's age. She also was a miniaturist and her name was Mary Betham. In addition to being a miniaturist she was known as a woman of letters. She published a *Biographical Dictionary of Celebrated Women*. She gave Shakespearian readings in London. Her father, William Betham, was headmaster of an endowed school at Stonham Aspel in Suffolk and published *Genealogical Tables of Sovereigns of the World*.

Now these apparently unrelated facts present too much in the way of coincidence. Anyone with some imagination can invent theories in which they interlock. The motivation may simply be petty snobbery, but that seems hardly likely. One feels that the truth may be much more interesting.

To get back to the FitzHerbert portrait. It was of course a close acquaintance with the style adopted by Miss Betham in the guise of Mrs John Read which preserved her anonymity, and delayed those interested in finding the answer for so long. Hitherto little had been known of her. Her existence had received a vague acknowledgment in the last Fleet Street label, and it was presumed that she was something of a nonentity, cosseted by her celebrated mother.

The responsibility shouldered by mama was transferred to John Read, the wealthy lawyer, on marriage. Having settled in the married state, Mrs Read required respectable distraction during her busy husband's frequent absences, and therefore opened a studio, by accident making some sort of a success of it. This is the kind of picture one had if one ever troubled to think of her at all. That has to be revised now. In the years between 1809 and 1815 the lady was responsible for other works of this calibre. Not all of them have been destroyed. A few will have survived and collectors must be on the look-out for them.

There is one final point. The frame, with its burnished gold glass was without doubt supplied, with its oval centre-piece prepared for the painter, by John Miers of 111 Strand. It is almost described in his trade label of 1791, and is just the sort of thing she must have used for her Academy exhibits. When John Field joined Miers they must have met as fellow exhibitors. There was undoubtedly competition between the two establishments. Here is evidence of friendly co-operation as well.

6. Some Alternative Collections

It SEEMS to me that this book is in danger of arousing the accusation that it legislates too severely for the profile collector. It has paid no attention to cognate matters which offer him distraction: to the handscreens painted by F. A. Gray [56]; to the Covent Garden types from Phil May's brush [65]; to the landscapes on composition by John Field [59], and the only known profile painted by Thomas Rowlandson [G] though there may be others undiscovered. The jewellery miniatures painted by so many artists deserve attention [58], and the lockets, rings and brooches which are the more easily acquired, and the lordly snuff-boxes [61], the equally aristocratic patch-boxes [62] and the magnificent seals which John Miers made [60], and which are so tantalizingly rare that one must avoid at all costs the enslavement of a craving to own one.

For the collector who has an affection for porcelain the English factories of Worcester and Bristol produced magnificent specimens in the eighteenth century. We might even briefly renounce our insularity and steal away abroad while the editor's back is turned to take a look at the products of the factories at Sèvres, Berlin, Copenhagen, Dresden, Gotha, Vienna, Fürstenberg and Meissen. Let us get off the chain for a while.

F. A. Gray is an artist of whom very little is known beyond the delightful little figures he depicted, often in absurd situations which bring them into some sort of relationship with present-day comic strip characters. They are presented in various forms of which, for my own taste, the most attractive is the handscreen. Even a perfunctory examination is enough to classify this as one of the most dangerous weapons in the feminine armoury. To speculate on the eyes that have issued their laughing challenge over it would be to digress unpardonably!

The pair depicted in plate 56 are a good example, being painted in 'The Pleasures of the Town' and 'The Pleasures of the Country'. The 'Pleasures of the Town' is surmounted by a familiar figure in an unfamiliar guise. Unless a mistake has been made, surely it is Cupid divested of his bow and quiver, the vine leaves of Bacchus substituted in their stead. He plunges into an orgy of revelry, shakes a puzzled head over an experiment with some library steps and no books, and arrives at a dismally lugubrious game of chess. Here he pauses long enough to recover slightly from the effects of the grape; then on he goes to discover a languishing but undeniably attractive young female who, for no known reason, is unaccompanied. He has magically recovered bow and quiver, and without pause looses off a dart at his victim. Since he has not troubled

to arrange a partner for the beautiful wall-flower, his eventual report on the action seems doomed to be classified as unsatisfactory.

The 'Pleasures of the Country' are clearly open-air and splendidly healthy. They even include work, which is a lesson for many of us today. Farm hands set forth gaily, undismayed by loads of agricultural implements and engrossed in the care of livestock. The picturesque is strongly in evidence, with hunting pink and hounds in couples carefully graduated as to size. They seem perilously close to the fox who, on the other hand, seems not in the least perturbed. The whole thing is companionable. There is a picnic party flying kites, bowling hoops, and indulging in every form of innocent amusement. Reserved until last, my especial favourite, the airy-fairy lady on the left-hand side. There she sits in her ethereal chariot moving peacefully forward in a two-dove —power progress.

There are a pair of similar hand-screens to be found in the Victoria and Albert Museum collection. They are also by F. A. Gray and show scenes and incidents at a musical evening party.

John Field, who was born in 1771, exhibited for the first time at the Royal Academy in the year that he joined John Miers's staff. He sent in from 111 Strand in 1800 an oil painting, 'View from the cottage side of the Serpentine River'. After four years' experience in the profilist's studio he found himself completely at home in painting on plaster of Paris ovals, and curious about their suitability for landscape painting as a change from his everyday portraiture. On one point he was quite clear, such landscapes must be painted in monochrome. Colour used, even with the greatest discrimination in a picture of two and a half by three and a half inches in size would be too much of a good thing.

So in 1804 he sent in his first landscape in monochrome and it was accepted. Not only was it accepted but its reception was distinctly encouraging. Another exhibit of the same kind was displayed in the following year and gradually it became a habit. By the year 1822 John Field could look back to the exhibition of fifteen of his monochrome pictures in the Royal Academy [59].

There was, however, an omission which, while it was unlikely to have worried him, is more than a little irritating to collectors of his work today. He identified his first monochrome in the Academy catalogue for 1804 as a 'View in Buckinghamshire' and after that there is no further identification until 1816 when he showed a 'View in Monmouthshire'. The exhibit in 1818 is a 'View at Thames Ditton looking towards Hampton Court', and the rest is silence.

Mrs Nevill Jackson owned a particularly attractive example of this kind of painting signed by John Field, which showed the toll-gate in Roehampton Lane being opened to allow a horseman to go through, while other figures including a milk carrier are seen approaching. Whether or not this was an Academy exhibit is unknown. He certainly painted a number of these landscapes which never hung in the Royal Academy, and don't misunderstand me . . . not because they weren't good enough!

SOME ALTERNATIVE COLLECTIONS

The year that saw the break in his Academy progress is significant. It was, of course, the year after John Miers's death. Field had become a partner with William Miers in carrying on the enterprise. For reasons stated elsewhere (p. 70) it seems likely that the business of profilism devolved entirely upon him, leaving William Miers in charge of all the subsidiary departments; the manufacture of jewellery pieces, and of picture frames and glasses with burnished gold borders; the bracelets made from human hair, and the hundred and one other things. Nevertheless John Field was no longer a hired man, and his future depended on the prosperity of the firm. He had no longer time to spare for exhibiting at the Academy.

He resumed the habit when the partnership came to an end, and his exhibit in 1836 allows us to deduce an interesting snippet of information, which is that he had read Edouart's *Treatise*. How do we deduce that? Elementary, my dear Watson. He called his 1836 exhibit 'Landscape *à la silhouette*', making use of the 'new' word which had received its first publicity in the previous year. A man who had spent thirty-five years of his working life in painting profiles could hardly resist reading Edouart's book!

From John Field to another artist nearer our own time: Phil May, one of the best, if not the best, of the fine school of black and white draughtsmen who flourished in this country towards the end of the nineteenth century.

May was neither a professional profilist nor silhouettist. He certainly painted a portrait in this method of the Polish poet Mickiewicz, and probably many others. These he did for his own amusement. He was a great believer in eliminating inessentials as is borne out by the reply he made to the managing director of the *Sidney Bulletin* for whom he was working as a cartoonist. He had been asked for a little more work in his drawings and said, 'When I can leave out half the lines I use now I'll want six times the money.' After all, the soundest watchword a young artist can adopt is probably 'economy of effort'.

May was born in 1864, and before he came of age his cartoons of Bancroft, Irving and Toole attracted the attention of Lionel Brough the actor-manager. Brough had, in addition to his dramatic prestige, some other interesting distinctions. He was the inventor of 'Pepper's Ghost', and also the originator of the street selling of newspapers. At the time he began to take an interest in Phil May's work he was, jointly with Willie Edouin, lessee of Toole's Theatre. His patronage launched May, and put him well on the way to success.

The three Covent Garden types reproduced here [65] were painted when May was staying at Hummun's Hotel in 1894. They were such as he would see daily, for the hotel was in Covent Garden. The lusty flower girl would not only be seen, but heard to considerable effect as well! Two years later he received his professional accolade. He became a member of the Punch table.

Charles Dana Gibson, the creator of the Gibson Girl, had a very high opinion of May's abilities. When asked why he rated him so highly he replied, 'His stuff's just *sticky* with

human interest.' The human interest that he depicted because he was fascinated by it himself was generally to be found in the lower strata of society. Therefore, sharing the fate of actors who play dustmen and are accepted as being dustmen, May is very generally accepted as a cockney. Nothing of the kind. He inherited his talent from his paternal grandfather who lived at Whittington in Derbyshire, where he was squire and Master of Beagles. He enjoyed a considerable local celebrity for his water-colour caricatures of friends and neighbours.

Those who are old enough to remember Desmond Coke and to have read his books will know that he, a man of catholic tastes, nevertheless had two overriding interests which jogged along comfortably together in harness. His collection of profile miniatures was perhaps nearest to his heart, but he thought that a number of them on his walls made for monotony. They needed a contrast, some sort of relief. He pondered and experimented, and eventually came to a decision. The best foil for shades, he decided, are Rowlandsons, and the best foil for Rowlandsons are shades. He meant, of course, Thomas Rowlandson's pastoral and genre drawings, and there is little doubt that he was right. These two make ideal and unselfish companions, each emphasizing the other's attractions.

Had a kindly fate any sense of what was due and fitting Coke would, at some time, have been permitted to claim ownership of the next rarity we are to consider.

You have, without doubt, had occasion to observe what a powerful influence money exercises over everything with which it comes in contact. You have? Good! Then you are well equipped to appreciate what is to follow.

Before the second world war Thomas Rowlandson was held in high consideration by only a few perceptive people. The majority, when his name was mentioned, merely thought of cartoons offensive to the modern taste, shivered slightly and dismissed the matter from their minds.

The war over, there came a sudden reversal of this situation. A single Rowlandson drawing, his 'Vauxhall Gardens' was offered at auction by Christie's in 1946 and sold for two thousand four hundred guineas, a bagatelle, had we known, compared with prices it would subsequently achieve. In the absurdly inflated currency of that year it was a whacking good price. A fellow whose work could command a price like that had to be good. So Rowlandson, always an accommodating chap, bowed his acknowledgments and became good suddenly. That is what money does. And the next rarity we have to show you is a profile miniature from the hand of the great Thomas Rowlandson himself [G]. Here he is, a military gentleman in all the glory of red coat, ultramarine facings, and gold badge on the white shoulder-sash. He is treated in an entirely different (but no less effective) manner than he would have been by the specialist military painter, John Buncombe. His title is 'Lieutenant in Charge of the Tower of London'.

Now before any critics of the eighteenth-century War Office start complaining about

the unfairness of putting a poor little lieutenant in charge of a great place like that, let me reassure them. The Lieutenant in Charge of the Tower of London was a Lieutenant-General. It is just one of those pieces of English false modesty which so endear us to the foreigner. The name of this particular Lieutenant, if any of you should be interested, was Lieutenant-General Charles Vernon.

As for the circumstances under which he came to sit to the great Thomas for his portrait, nothing whatever is known. My personal fantasy in which he was taken to enjoy hospitality at the Tower by his friend Henry Angelo, the fencing master, starts promisingly. But when the conversation turns to the Infantry Depot at Newport, Isle of Wight, and has Vernon regretting his inability to have his portrait by John Buncombe, and Rowlandson offering to remedy the deficiency, it turns sour on me. This is altogether too contrived and I am certain that the truth, if it ever comes to light, will be much more interesting.

There is one more point which must be stressed about this particular portrait. It is such a rarity that there are bound to be doubts raised as to its authenticity. There is no doubt about that whatever.

It must first be stipulated that there was no faking of these shades before the first Nevill Jackson and Desmond Coke books were published in 1911 and 1913 respectively. Up to that time they were considered valueless, and not worth a faker's consideration. Soon after their publication the Bath factory opened, and elderly gentlemen copied Edouart groups laboriously on flat glass, while others adorned their results with maple frames, which at that time were to be found by the dozen in any junk shop at an average price of sixpence each, the result of their combined efforts being only convincing to those who had never heard of Edouart. Later these industrious gentlemen became slightly more original, and started turning out the fox-hunting and shipping pictures which you must have seen, also in maple frames.

However, long before all this happened, in fact at the turn of the century, the Rowlandson likeness was in the Wellesley Collection, where it remained until that collection was sold at Christie's on 19 June 1917. (No less than one hundred and thirty portraits by John Miers were offered at that sale!) It was catalogued by Christie's as 'by Rowlandson' and passed to the collection of Sir Henry Sutcliffe-Smith. That collection was bought by Messrs H. Blairman and Sons Ltd, and exhibited at their Grafton Street Galleries. If you will pardon a momentary personal intrusion into this narrative, I first became acquainted with the Lieutenant-General when he was reproduced in a book in Unwin's *Chats* series in the late 'twenties. I carried him stored in my memory with no hope of a meeting until I recognized him at that exhibition. In April 1949 he became mine. I can wish you no greater joy of acquisition.

So you see that the Rowlandson shade has been known since the beginning of profile-collecting time. Whether Rowlandson ever painted another, who can say? My own answer to that question is: Wait until the day when collectors have decided unanimously

that he didn't. Then another will come to light, and it will be even finer than the Lieutenant-General.

Of the English porcelain factories that introduced shadow portraiture into their production the principal exemplars were those at Worcester and Bristol. George III, in response to an invitation, visited the Worcester factory in 1788 during the Flight-Barr period, and later in the year it received the Royal Warrant. Before long it was producing a steady stream of pieces bearing portraits of George III accompanied by such inscriptions as 'An Honest Man's the Noblest Work of God' and 'The Nation's Hope'.

In the year of the King's Jubilee the stream swelled to a torrent. No monarch had celebrated a jubilee since Edward III in the fourteenth century. In consequence this was an exceptional cause for rejoicing, and the citizenry went to it with a will. Even more enthusiastic was the rustic community, for after all was not George III a 'farmer king'?

The Chamberlain factory which, in the year 1800 had taken over the manufacture of Worcester porcelain and was to continue it for nearly half a century, must have found the number of drinking mugs they produced and sold with such inscriptions as 'Glorious Jubilee' and 'Long May He Reign' accompanying portraits of the monarch, highly satisfactory. The liquor that flowed down the celebrating throats was ample to banish a single thought about the unsatisfactory state of the King's mental health. The thought of mugs carelessly smashed in that monumental spree is enough to unsettle any porcelain enthusiast today.

In the illustration of porcelain in the Pollak Collection [57] the two-handled vase on the left-hand side is from the Chamberlain factory. It had the King's portrait surmounted by the inscription 'Dear to his Subjects'. Below it, and to the left is a beaker with a similar portrait and the inscription 'Long May He Reign', this one being clearly a survivor from the jubilee carousals.

The factory at Bristol started in about 1770 with a take-over of Cookworthy's Plymouth factory which had enjoyed a very short lease of life. They were the only two 'hard paste' English factories in the eighteenth century. Bristol produced a pink-scale pattern mug to celebrate its new proprietor, Richard Champion. It had his shadow portrait and initials, but how many of these the factory made is not known.

Porcelain enthusiasts are well aware of the contribution which came from the Coalport factory. Made circa 1810 to the order of John Julius Angerstein, a financier and art-lover whose bequest of fine pictures forms the basis of the National Gallery collection, it consists of a dinner service of one hundred and thirteen pieces [63, 64]. Bordered with a Greek design of leaves and husks on an apricot ground, gilt lined, it contains what at first glance might appear to be the imaginings of a profilist much concerned with domestic felicity. Two or three toddlers, usually with mother but occasionally alone, are depicted enjoying childish pursuits which emphasize infant grace. Their elfish symmetry apart, these children are full of life and movement, and would have a wide appeal on the

89

strength of these attributes alone. But in addition there is a family tradition which places them among its members, and there are those who believe that mother is the beautiful Amelia Angerstein.

John Julius Angerstein was born in St Petersburg in 1755, a birth on the 'wrong side of the blanket'. A great deal of mystery surrounds his early youth, as it does that of William Lock, who later became his greatest friend. Little is known of his mother, but it is clear that there was no neglect on his father's part.

At fifteen John Julius arrived in London to serve an apprenticeship in papa's counting-house. He was no impoverished apprentice. At twenty-one he was an underwriter at Lloyds. It was not long before he became Lloyd's first chairman. During all this time a friendship had been building up between himself and William Lock, a wealthy and good-looking young bachelor. Their lives appear to have been crowded with dramatic events which include a ruined financier and his suicide, his widow's advances to John Julius, and the near break-up of the friendship between the young men that was caused. The details are hardly a matter for this book, but they were the kind of people to whom things happen.

Eventually the families of Angerstein and Lock were united by the marriage of John Julius and Amelia, with the result that a social circle formed around them containing many names famous in the world of art and letters. John Julius's generosity towards charities which seemed to him deserving became recognized. Sir Thomas Lawrence, Benjamin West the historical painter, Fuseli, Mrs Delany who carried so much influence at the court of George III, and Fanny Burney were all numbered among their friends.

The authorship of the profiles has been widely canvassed, and while none of the fore-going can be suspect, there are two other members of the circle who can. Amelia's favourite brother, William Lock, had the required ability, and so had their friend, Lady Templetown. Figures of this kind are simpler, and therefore more difficult to attribute than the professional likenesses with which we are mainly concerned. The artist was probably a highly-skilled amateur, concerned only with what was to be stated, rather than the projection of his own personality as the professional must always be. So far no attribution has been found possible.

An inflexible rule which I made for myself was that no prices should be quoted in this book, and I see no reason to break it. You are unlikely to have any chance to buy this service, since it has reverted to a member of the family. You might, of course, be lucky enough, as was Desmond Coke, and at least one other collector I know, to run across one or two odd plates. In such a case it would be most unfortunate if you had no inkling at all of their value. Taking this into consideration, it is perhaps advisable for me to break my rule and tell you that in 1965 the Angerstein service was sold at Sotheby's for ten thousand pounds.

We will now take leave of this country and glance at what is going on in Europe.

In France the Sèvres factory produced coffee cups and saucers with profiles of Mira-beau and other notabilities, highly attractive as was the rule of the leading French house, but making no attempt to compete with England in regard to quantity.

Denmark's Royal Copenhagen Porcelain Factory was founded somewhat later in 1770. From it came a series of plaques bearing shadow portraits of Danish kings and queens. They range from King Charles IX and his Queen Louise onwards, and include a likeness of Queen Alexandra, wife of our Edward VII, the subject of the plaque in the centre (front) of our illustration [57].

Severe competition on the score of quality and instantly impressive appearance came from the Viennese factory during the first decade of the nineteenth century when they produced a coffee service with a shadow portrait of the Archduke Charles surrounded by a most striking rayed decoration. A single cup and saucer from this service was sold in 1928 for the sum of £200, something of a record for that time.

Germany appears to have adopted this kind of porcelain as whole-heartedly as any other country. Meissen made pieces bearing grand ducal portraits conforming to that factory's high standards. Exceptionally attractive too, were the dark blue and gold pieces which emanated from Dresden during the Marcolini period circa 1796 with profiles made probably to customer's requirements.

The Gotha factory would seem to have found something individual in the form of decoration. It produced plates having on their borders profiles of up to half-a-dozen members of a family, alternating with floral and patterned inserts.

The Berlin factory did not lag behind in the production of profile pieces, notably a mug bearing a portrait of Frederick, King of Prussia, surrounded by a laurel wreath in colour. This bears the Berlin Sceptre mark.

Nymphenburg and Höchst, two other notable factories also made celebratory pieces. Fürstenberg was responsible for the large tray and coffee service illustrated, while the cup and saucer on the extreme right of the illustration comes from Fulda, a factory which has been enlarging its circle of admirers considerably during recent years.

To return to Britain, the collector for whom wall space is an important consideration may find the miniature jewellery pieces made by so many of the profilists an attractive solution to the problem. A case such as that illustrated [58] displays admirably the work of a number of artists, and takes less than half the space of one of Monsieur Edouart's large groups. Furthermore it is pleasanter to look at, and your women friends will be more apt to sympathize and ask intelligent questions, rather than sneer and talk about your craze for the quaint.

During a recent visit to the Victoria and Albert Museum to refresh my memory of the Desmond Coke collection, the case containing Miers's jewellery pieces, lockets, brooches, pins and patch boxes with plain gold frames, or frames enhanced with pearls, was brought to me. A number of teen-age students who had been quietly pursuing their various

studies with concentrated attention were sufficiently interested to leave their seats for a closer inspection. Whispered questions about the exhibit, which clearly fascinated them, were addressed to me. This case, it seemed obvious, rather than being kept hidden until asked for, should be on view to the public.

Most collectors will have shared my experience that uninformed persons will gaze at a collection of bust-size profile portraits hanging on a wall and evince no sign of having seen them. Here was evidence that this is impossible with jewellery miniatures, whose fascination is universal.

A glance at the chronological list will show you that more than a dozen of the artists included in it advertised that they painted jewellery pieces. Many were inspired by them to do their finest work. The examples most likely to come to you will be by Miers or Field, since their output exceeded that of their competitors. Charles, Rosenberg, Spornberg and Isabella Beetham all painted a sufficient number for you to be optimistic, but if you particularly desire an *églomisé* specimen, once again you will have to look abroad. The French painter Forberger (not to be confused with Fabergé) is one to look for here. An example of British *églomisé* would be a very considerable rarity.

And talking of rarities, here is one you are most unlikely to run across. Nevertheless, it is as well to be on terms of recognition should fate decide to pick on you! It is, you will observe, one of the secret seals which Miers began to make round about 1812, when the last label issued during his lifetime appeared [60]. This one bears the signature 'Miers & Field' under the bust-line of the gentleman whose likeness it carries, and was therefore painted after 1821. Not long after, one would think, for the head is as neatly proportioned as was the case in Miers's lifetime. It is devoutly to be wished that no one ever discovers one of these things containing, instead of the likeness of an elderly and prosperous gentleman, a portrait of a lovely woman. It would seem quite unnatural!

7. Decadence

WITH the arrival of the nineteenth century the art of the profilist began to decline. Certainly half-a-dozen new names appear in our chronological list from 1801, and with equal certainty no blame for the decline can be attached to any of them. We are acquainted with Thomas Lovell as John Miers's assistant, and Mrs John Read as Isabella Beetham's daughter, so we could be pardoned for describing them as survivors from the previous century but for the risk of them being thought of as centenarians!

Henry Hervé with his connections with the Royal Academy and Hintor Gibbs with his with the Bedfordshire Militia are equally blameless, and the same must be said of London and Frith. They need no defender for they do not stand accused. The man, more than any, who does need a word in his defence is John Field. How often has one heard it said by the unthinking, 'when John Field started bronzing Miers's shades the rot set in, and decadence was on the way'.

There are two points in that statement which demand questioning. The first is 'bronzing Miers's shades'. Without the slightest intention of being dogmatic about this, I must point out that there is a strong probability that the shades Field was bronzing were not Miers's but his own. The business, by this time, was working to its full capacity, and Miers was too capable an organizer to waste time on detail which could be put to better use on administration.

The second point is more important. The implication here is that decadence set in *because* Field bronzed the shades. This is quite untrue. None could have done this work better, and very few indeed could have done it as well. There was no rule in any book, written or unwritten, which said he shouldn't do it until Augustin Edouart, for his own reasons, invented one thirty years later. Let us be thankful there wasn't, for we should have been robbed of these delicate delights.

Neither can Edouart bear any part of the blame for decadence. Whatever else may be said against him (and I shall be as quick as anyone to say it) he was in the top rank of free-hand cutters, and perhaps gave a certain stimulus to the art when it was needed rather than assisted its decline.

The principal reasons for its fall from grace were the multiplication of fairground operatives, the growth of machine-cutting, and the silhouettists who followed in Edouart's wake.

8. The First Silhouettist

IN THIS country the first appearance in print of the word 'silhouette' was in the *Monthly Review* in 1798. It was a passing reference, and had no impact on the then population of nine million souls. There is no recorded case of a profilist clamouring for his printer to describe him as a silhouettist. Had the matter been allowed to rest there a certain amount of unpleasantness would have been avoided, a deal of reiterated explanation spared. It would have been unnecessary for me to explain, as every writer on this subject is forced to do from time to time, that Etienne de Silhouette was a cheeseparing and unpopular Finance Minister in eighteenth-century France; that he cut paper portraits for his own amusement; that his critics, who comprised most of the French population, gave his name to these likenesses, to stigmatize them as cheap, inconsiderable and nugatory.

This would have been of little moment had the insult been confined to the work of the first silhouettist to practise in this country, and those who followed in his footsteps. The man who publicized the word and gave it its place in the English language was an emigré, and his name was Augustin Amant Constant Fidèle Edouart. The publication of his *Treatise on Silhouette Likenesses* by Longmans in 1835 was what did the damage. After that there was no going back. The 'vile word' as Desmond Coke called it (and how one must applaud his choice of adjective) was applied indiscriminately by the uncaring British public to what went before as well as to what came after. What came after Edouart, one must admit, largely warranted the insult. In connection with what had appeared before he impinged upon the scene, it could not be justified at all.

The delightful creations of Miers, Beetham, Spornberg, Buncombe and Mrs John Read were labelled 'silhouettes' which was like splashing them with mud. Monsieur Edouart cut slightly stiff likenesses out of black paper [66, 67], so Phelps and Buncombe who used colour and Mrs John Read whose Aquatinta Likenesses were by no means stiff were 'incorrect'.

You may have noticed that Augustin Edouart is hardly my favourite man. Even so, one must be fair to him. My reasons for disliking him are that he was overbearing, insensitive and a *grippe-sou*. The first two charges will be dealt with as we get on with his story. The third is evidenced in his work.

Just one more of those congested family groups with too many of the family, topped up with some of the servants, and the umbrella stand, the baby's cot and the dog's basket all ranking as extras and charged for accordingly may have a disastrous effect on my social

94

behaviour! This was no way for an artist to go to work . . . and he knew better. Catch him one bright morning when his small daughter, dancing her own private ballet with a feather duster in his library of duplicates has inspired his scissors, and you will have the most delightfully simple creation of an ethereal sprite that anyone might covet. The thought of it encourages me to an effort to avoid unfairness.

Augustin Edouart, born at Dunquerque in 1789, died at Guines in 1861. He came to England as an emigré in 1814. In that year, at the age of twenty-five, he was a married man with five children. His first attempt to fend for his family in a foreign country made him a teacher of the French language. With the threat of Napoleonic invasion an ever-present Damoclean sword, the English showed a strange reluctance to become his pupils. It soon became clear that he must try again.

So next he practised hair-work. He made portraits of animals; favourite dogs and horses particularly. He modelled them in wax which was then covered with hair from their own bodies. The results are said to have been extremely lifelike. From this he graduated to pictures resembling engravings and made from human hair. When he was convinced that the hair was not fine enough for his purpose he split it lengthways with his scissors. Thus he is said to have gained masterly control over his instrument.

Edouart became a profilist partly through the death of his wife, which made a new interest for his mind essential; partly through a dare at a party.

It was in 1825, at an evening party at which some rather pert young damsels were present that he criticized a profile portrait of another guest. His criticism was delivered with a weight and authority which caused the young ladies to challenge him on behalf of the unknown profilist. 'It is easy enough to criticize,' they said, 'but you try to do better.' There were several of these sallies until eventually he took action. Stung, he folded a sheet of paper. Piqued, he seized his hostess's embroidery scissors. Inspired, he posed the sitter in a favourable light. Triumphant, he cut a perfect likeness which showed up every fault in the one he had criticized! That is the way he tells it, and there is no other witness.

From that fair start he immediately inaugurated a practice which ensured him his heart's desire, the wide recognition of his own importance. He desired that above all things, but was not to enjoy it during his lifetime.

The practice? It was such a simple thing. He had folded the paper in order to cut two likenesses at once. While one was handed round for inspection, and praised with warmth and enthusiasm as he modestly tells us, on the back of the duplicate he wrote for his own records the sitter's name and address, his apparent age and such other details as he deemed important.

Since Edouart was to be patronized by the Duke of Gloucester and many other members of the nobility, in addition to becoming silhouettist to the royal family of France; since he was to take likenesses of most of the distinguished persons of his day in England, Scotland and Ireland; since on top of all this he was to pay a ten-year visit to

America and collect some thousands of portraits there, the value of his well-documented duplicates to historians and others will be readily appreciated.

Of his earlier likenesses in which backgrounds were used, such as that of Nathan Mayer Rothschild at the Royal Exchange, Sir Walter Scott in his study at Abbotsford [66], and Paganini accompanied by an orchestra, he says, 'I have backgrounds adapted to silhouettes which impart greater interest . . . I have Artists (and I may say not inferior ones) employed to draw these backgrounds.' He has nothing more to say about the matter, and gives no hint as to who these artists are. One of them managed to slip his initials, G.F.S., with or without his employer's permission on a drawing or two, but they have not led to the discovery of his identity.

In the course of his itinerations Edouart paid frequent visits to Edinburgh. In 1832, the royal family of France being there in exile and pining, as such exiles must, for distractions to pass the heavy hours of waiting, he found himself invited to Holyrood Palace to portray and amuse the court circle in the evenings. In spite of the fact that his feelings towards the Bourbon family were none too cordial since he had suffered considerable losses in consequence of their restoration to the throne, he came to the sensible conclusion that this was an invitation which it would be unwise to refuse.

On his arrival at the palace he was presented to the King by the Duchesse de Berri. He says that the King and the royal family had seen a considerable variety of black shades and were unimpressed by them to the verge of dislike. 'This feeling,' he says, 'was soon removed when they saw the nature of mine.' Which may well have been good reporting but was exactly the kind of remark we should have expected from him.

Every member of the royal circle from King Charles X to his *valet-de-chambre*, by way of the Duc de Bordeau, Princesse Louise, and the Duchesse de Berri were taken; some eighty portraits in all. They have their importance in the history of France and anxiety was felt when for many years they disappeared from public view. However, early in the present century they came to light again, and were purchased by the Bibliothèque Nationale in Paris.

Three years after these likenesses were taken in Edinburgh, Edouart's 'treatise' was published. He called it a *Treatise on Silhouette Likenesses*, as we have seen, but it is rather the silhouettist's autobiography, and shows him to take a somewhat doleful view of life.

Early on we come to a chapter headed 'The Vexations and Slights my Profession has Brought Me'. By the time he has got that one off his chest even he realizes that a wet blanket hangs soggily over the proceedings, so he tries to put matters right with 'Advantages and Gratifications I have Received from my Profession'. Correctly fearing that the boasted Advantages may fail to gratify his readers, he gives up the struggle. The next chapter is headed 'The Grievances and Miseries of Artists'. He displays a certain facility for getting even with those responsible for his Vexations and Slights, as witness the following story.

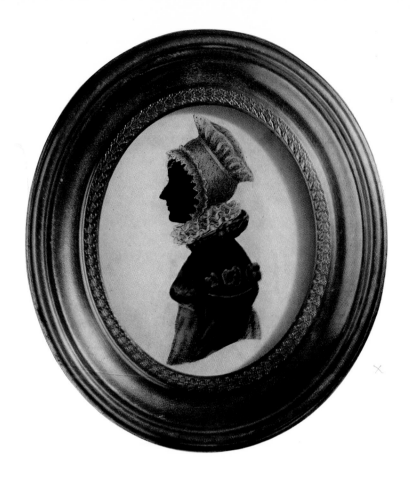

H. W. Phelps. Portrait of a lady. Painted on the
underside of convex glass. Ormoulu frame,
$4\frac{1}{2}$ in. x 4 in. It is remarkable in that the filling
is a blend of wax and plaster of Paris which
has kept its colour and avoided cracking, and
it shows that Phelps had at least three distinct
methods when using colour. (Page 64).

While travelling by coach from London to Edinburgh as an inside passenger, he found himself with three very agreeable fellow-travellers, two ladies and a gentleman. The quartette appear, without conscious effort, to have constituted themselves into two couples and passed the time gaily in conversation and badinage. The journey, anticipated as a weariness, materialized as something of a frolic, and they were on the very best of terms with each other when the coach brought them to an inn at which they were to dine. The gentlemen assisted the ladies to alight, and in the moment of so doing Edouart's newly-found friends were hailed by an outside passenger. They were all obviously well-known to each other, and quite thoughtlessly they seated themselves together at table. Edouart, to his annoyance, was excluded from their company. To make matters worse he recognized the intruder as a man who had sat to him for his portrait. 'We took no notice of each other,' he says, 'it would have been impertinent on my part, and on his it would have been vulgar.'

From his position at table he had no difficulty in keeping them under observation, and it soon became clear that he was being discussed and his identity disclosed, a disclosure which created considerable amusement. Anticipating the coolness with which any attempt to rejoin the trio would be met, he left the dining-room and went in search of the guard. Some money changed hands and Edouart became an outside passenger for the remainder of the journey. His place inside the coach was taken by an 'old sailor'. He says nothing further about his seafaring stand-in, but there is a note of grim satisfaction in his account which bodes ill for the trio!

In Edouart's early days as a profilist it was his evening pleasure to walk those London streets where others of his kind had their studios. He would inspect such work as was on exhibition, afterwards recording his opinions for use in the *Treatise*. Since he had no other instrument than his scissors, and very seldom used them for anything less than a full-length, he can hardly have felt anything but contempt for Messrs Miers and Field's display of bust-size portraits. It must be admitted that when a sitter caught his interest, which clearly happened frequently, he had more to tell of him than any other cutter, more than some of the painters too!

In my opinion his most impressive work is a self-portrait [67]. He is seen standing in the act of cutting a silhouette of the actor, John Liston. The figure emerges from his scissors as though wriggling in an attempt to come to life. Your eye follows the black paper cut away seeking, but failing, to find a place where, if put back, it would not fit! The puzzling thing is that while he could use scissors so effectively he was incapable of working with a brush. One speculates on whether he ever tried, and feels sure that if he had he would certainly have had some measure of success. After all, painting is a matter of what the eye sees and what the hand is dextrous enough to record. We have ample evidence that Monsieur Edouart's eyes and hands were fully equipped to do the job. This inevitably leads to the conclusion that he was completely satisfied with what he did, and convinced that no one could do better.

G

THE FIRST SILHOUETTIST

Now bear with me a little longer, and compare his approach to his art with that of Isabella Beetham to hers. In her beginnings she was a cutter, usually of bust-portraits. They are quite as good as any bust-portraits Edouart could have cut. Did she sit down, do nothing else for the thirty-five years of her career except perhaps cut a full-length or two, and proclaim her work as the standard by which every other profilist should be judged? This is a rhetorical question which in this isolated instance shall not receive a rude answer! She did nothing of the kind. By the time she moved into her Cornhill studio she was a fully qualified artist with the brush, and before the move to Fleet Street was made she had joined the élite of her profession and become a glass-painter. Furthermore, by the time she had reached the height of her powers there is no record of her announcing, 'See! this is what *I* do! Let no dog do otherwise!'

We have rather got away from Edouart's evening peregrinations. Let us return to them. After one such he is full of condemnation for 'the kind of profiles with gold hair drawn on them. . . .' This is, of course, a direct attack on the work of John Field, and is what Mrs Nevill Jackson had in mind when, after praising Field's skill, she added, 'a purist in taste with regard to shadow portraiture cannot altogether approve.' But why not? How has taste been affected? Edouart then goes on, 'coral earrings, blue necklaces, white frills, green dress and yellow waist-band—the face being quite black forms such a contrast that every one looks like a negro. I cannot understand how persons can have so bad, and I may say childish taste. . . .'

Now that, Monsieur Edouart, is quite unfair! If you have seen a profile in which all these colours were used at one and the same time we would agree with you that it was in childish taste. Nothing of the kind has survived into our own century, and we are inclined to doubt whether it was ever perpetrated in yours. Most profilists understood that they would do well to please their clients, and children were not cash customers of the profilist in any large numbers.

Some years later when he opened his exhibition in Dublin to show hundreds of likenesses taken during his English itinerations, he advertised them for the first time under the new name 'silhouettes'. In view of his opinions it is one of life's oddities that the impression should circulate in the town that these 'silhouettes' were to show something highly novel in the way of colour. His feelings may be imagined when he heard the first arrivals remark disgustedly, 'Why they're nothing but old black shades.'

He returns to the attack on his own fraternity with another lofty pronouncement: 'It must be observed that the representation of a shade can only be executed by an outline. It is a pity that Artists should give way to these fantastic whims and execute works against all rules.' Since he was only now publishing his rules it was a little optimistic to expect obedience to them in the past.

What was the effect of that reproof? Such artists as heard of it went on with what they were doing without paying the least attention, which was good. The cognoscenti, the observers and those standing on the side-lines bowed their heads and gave it the

respect due to a divine judgment delivered by the ancient of days in person. That was bad.

In fact it was one more move in a campaign to persuade all who would listen that penny plain was to be preferred to tuppence coloured. While his reasons for conducting such a campaign are not immediately evident, there may be a clue to them in a conversation he reports with a dissatisfied client who charged him with extortion when a bill for five shillings was presented. 'Five shillings for a portrait which took you but one minute to cut,' said his irate customer, 'at this rate you value your time at nearly fifteen guineas an hour. I'll not pay it, Sir. I'll not pay it,' and out he stormed.

He was a well-known local resident and in a few days he was clamouring to be allowed to pay. Edouart had prepared a portrait of him and placed it in his window. A corkscrew descended from his feet; its handle grew from his head. A show-card announced that it was a 'Patent Screw for Five Shillings', and a brisk trade was being done in copies at five shillings each. It was the kind of joke with great appeal to people at that time, and they laughed even louder when they heard that the victim, having called and paid the disputed amount, demanded that the offending likeness be removed from the window. 'Oh no!', said Edouart, 'not yet. There is still a great demand for copies.'

To me it seems highly probable that here lay the reason why Edouart made no move towards the upper echelons of his profession as Isabella Beetham had done so successfully. It was a sordid matter of cash in small amounts, which in the end reached a sizeable total. The point is now made that he was a *grippe-sou*. In addition to his miserly streak he had little of that suavity one would expect from a Frenchman following such an occupation in a foreign country. In fact he was not above a brawl with a client who disagreed with him, and one such brawl developed into quite an ugly scene.

It would not have been so bad if it had been another man with whom he was at loggerheads, but it wasn't. It was a lady—a lady with a wart on her nose! No reference was made to this slight disfigurement, either by sitter or silhouettist before the sitting began. It was not until the likeness was completed and had been handed to its original that the lady remarked, 'Oh! but you have put a wart on my nose!' which would seem to show that she was unaware of having any such thing. 'Madame,' said Edouart, 'you have a wart on your nose.' He said it almost as brutally as any Englishman. 'But it is such a very s-m-a-l-l wart,' said the lady, acknowledging its existence at last. 'It is a medium-sized wart,' returned Edouart. 'Then if it is a medium-sized one why do you make it so large? You must take it out,' commanded the lady. 'If I do that, madame, no one will recognize the likeness,' countered Edouart nastily. 'If you won't, then I will,' from the client, at the same time making a smart dive and taking possession of his scissors.

For a client to touch those scissors was practically *lèse-majesté*. Edouart says nothing, seizes her wrists and endeavours to shake the scissors free. He fails. They are both red-faced and breathing heavily. At that moment there is an interruption, and Edouart instinctively releases his grip on the lady's arms. People in such a position, after all—

so easy to misunderstand. The lady immediately takes advantage of the respite, snips the wart off the portrait's nose, and makes a triumphant exit. As a servant of the public, was he, perhaps, a trifle overbearing?

There is one aspect of this man which should excite our sympathy. He was curiously and painfully over-sensitive. His Slights and Vexations, his Grievances and Miseries meant much more to Edouart than they would have done to another. He brooded on them. He had none of the average normal man's capacity for shrugging them off with a laugh.

He has a story in the *Treatise* which illustrates that excessive sensitiveness. He was visiting a town in the course of his itinerations where he had been offered hospitality during his stay by a local big-wig. His host greeted him on his arrival, and they enjoyed the early dinner then customary in the provinces. During the meal the host remarked that he had visited 'the castle' and had mentioned his guest's name and occupation to 'the Governor' who seemed interested and expressed a wish for a meeting. It was suggested that they visited him after dinner.

To this Edouart cordially agreed. That Governors of castles should invite him accorded with his ideas of his dignity. The visit was paid accordingly, they were well received, there was some general conversation. Soon, however, there came a time when they were at cross-purposes. It originated with the Governor and went something like this: 'Well now, suppose we get ready and see what you can do?' To which Edouart replied, 'I did not understand that you intended to try me out. I have not brought my instruments.' 'You will not need your instruments. I take it you do not intend to finish me?' And Edouart: 'I could hardly work on you without my instruments, and I never leave out the finishing touches.'

How long did this sort of thing go on before it was discovered that his host had invited him to stay, being under the impression that the profilist was a pugilist? When the discovery was made, did Edouart chuckle and decide that the friends were pleasant enough fellows, if more than a little stupid? Nothing of the kind. He decided that his precious dignity had been affronted, and proceeded to sulk about it.

This trait in him is reflected in his work. He could show character in a flash, but a laughable situation passed him by. It was a loss to him and to us, for the people among whom he lived were much better material for humour than their immediate predecessors.

In the time of the early profilists, that is to say in the second half of the eighteenth century, the key-note of the clientele that flocked to their studios was a suggestion of romance. They were, in fact, a highly theatrical lot. Comedy could be left, more or less safely, to Rowlandson and Gilray. For the profilist they were, every man and woman of them, skilled and somewhat temperamental dramatic actors. With the dawn of the nineteenth century a change came over all that. The silks and satins, the brocades and laces came off, but their owners still remained theatrical. In their place, on went the funny clothes, the stove-pipe hats, the baggy tweeds, and every man and woman was an unconscious comedian.

By the end of the century the comedy element had flowered and Phil May, and the splendid school of *Punch* artists saw it all around them. May, for his own pleasure, painted it in silhouette. Edouart, poor fellow, never suspected its existence, and you will find no trace of it in his work, even by accident. This and his complete inability to find a pleasant comment on the work of any of his confrères are two of the least likeable features in his make-up. They were largely responsible for the ridiculous boast which resulted from his evening peregrinations: 'I decided that I would raise this matter to an art.'

The diversity of his work is shown by the catalogue of his exhibition held in Dublin in 1834, which included portraits of the Dukes of Gloucester, Wellington and York, the Bishops of St Davids, Bristol and Bangor, and Amelia Opie, poet and novelist and widow of the Cornish Wonder, John Opie, who was herself a cutter of silhouettes. There were likenesses of Sir Walter Scott in his study at Abbotsford, Baron Rothschild at the Royal Exchange, London, the French Royal Family and the members of the London Stock Exchange. A notable exhibit showed the officers of the Ninth Regiment of Light Infantry. There were numerous portraits of eminent actors and musicians, a satirical presentation of the Temptation of Saint Anthony, with monsters, imps, goblins and fairies.

Views in the various towns he had visited had their place and included Royal Crescent, Bath, High Street, Cheltenham, and Park Street, Bristol. These were peopled with known local characters, beggars, Sedan chairs, crowds and a bull!

The foregoing is but a tiny sample of the delights offered. The Dublin press reported well on the exhibition, crowds attended daily, and Edouart remained in the city for nearly a twelvemonth and took upwards of six thousand likenesses.

When he felt that it was time to move he visited Killarney, Cork and Kinsale, where it was said that the number of portraits he had taken was surprising for so small a place. Encouraged by these successes he went on to visit Fermoy, Limerick, Youghal, Mallow and Bandon. He clearly enjoyed working in that country and was still there in 1839 taking likenesses in Ulster. He crossed to Liverpool and worked there for a few weeks, after which he sailed for New York. With him went all his duplicate albums, and the material for his exhibition.

His arrival in New York saw the renaissance of the exhibition accompanied by an even greater success than it had previously enjoyed. His visit to America lasted ten years. During that time he took portraits of the poet Henry Wadsworth Longfellow, President Harrison, Daniel Webster, Secretary of State in the Cabinet of President Harrison, President John Tyler, who succeeded President Harrison without election, President Martin van Buren, Senator Henry Clay and Benjamin Franklin. He took high-ranking army and naval officers in uniform, senators, orators, presidents of corporations, colleges, institutes and banks, and the founder of the New York Jockey Club.

In his journeyings round the continent he saw the other side of the coin. He made

contact with the redskins. His albums included portraits and groups of them, and showed that he had devised a special technique for portraying them. The cuttings were done in brownish cartridge paper, and were afterwards tinted with sepia and lined with white. The groups show Red Indians dancing and playing musical instruments. They are wearing their ceremonial dress, and the interest they have aroused in him is reflected in his spirited cutting. There is, unfortunately, no documentary accompaniment, and we are left to guess how he met these people and, more important since it is the one and only time we can suspect him of using a brush, how that came about, and whether he or someone else did the painting.

By the year 1849 he felt that having reached the age of sixty and spent ten years in America, that great country had little left to offer him. For some time France had been calling, a call so insistent that he felt it incumbent on him to answer. Eventually the answer could be no longer delayed. In November of that year he took passage in the *Oneida* and sailed for home.

It was from the first an ill-fated voyage. Once in the Atlantic storms were encountered and persisted throughout the crossing. The unaccustomed stress on an elderly man had robbed Edouart of much of his strength. In Vazon Bay, off the coast of Guernsey, came the culminating tragedy. The vessel struck the rocks and became a total wreck. Luckily there was no loss of life. This was largely due to the inhabitants of the island, seafaring men with experience of such happenings. The vessel and most of her cargo were lost. Edouart lost his personal luggage which included his American diaries, but his volumes of duplicates which had been very carefully stored in stout packing cases were brought ashore and suffered little damage.

The shock had rendered him incapable of constructive thought or action. His plight aroused the sympathies of a kindly family named Lukis. They gave him a home, took care of him, and nursed him until he was again fit to face a normal existence. When the time came for him to leave them his main concern was how he could show his gratitude. He owed them so much and he had nothing to give; nothing in the world except his books of duplicates. So he gave them those; and that is how so many of them are now in the hands of collectors.

There is little more to add beyond the introduction of a personal note. In the early 1930's I was offered a volume of Edouart's duplicates by a dealer in Notting Hill Gate. It was in many respects similar to those shown in the illustrations of his library of duplicates, and on the back it was inscribed DIEPPE. On opening it one realized that it was unique. The portraits (of which there were no great number, for the volume was by no means full) were cut in blue paper and mounted on pages of pale grey. But, more unusual than this, the features, eyes, mouth, hair and ears were drawn in with white paint. Details of the dress were similarly drawn, and decorative touches added. The drawing was just good enough but by no means superb.

It took a little while to realize what one was examining. It was, of course, Edouart's

recantation; his one and only bow to the force of public demand. In effect it denied: 'the representation of a shade can only be executed by an outline. . . . A pity . . . that artists should execute works against all rules.' One could hardly help but shed a tear for him. The old dog who had been forced to try new tricks.

9. The Coup de Grâce

In 1839, the year in which Augustin Edouart, aged fifty, left Britain after fourteen successful years to further his career in America, one of his fellow-countrymen was enjoying the triumphal celebrations which, in *his* fiftieth year, attended the long-sought discovery that had now crowned his life-work. Praise was being heaped on him from every side; his country recognized the importance of the discovery and he was appointed an Officer of the Legion of Honour. The ironic facet of this comparison is that the life-work being celebrated was to have some effect in superseding the life-work still in active progress. The newly-made Officer of the Legion of Honour was Louis Daguerre.

Daguerre, like Edouart, was born in 1789. There the resemblance between them ceases. He was a visionary, a man who, for a number of years, had been the slave of a fixed idea. The dream which motivated him was that some day, God willing, he would discover a method of obtaining permanent pictures by the action of sunlight. Time and again he had seemed on the verge of success. Time and again he had encountered failure.

In 1826 matters came to a crisis. He learned (how is unknown, but bad news travels fast) that there was a rival in the field, another bent on his own objective. He made discreet inquiries regarding his rival's identity and found that he bore the improbable name of J. Nicéphore Niepce.

Daguerre entered into a correspondence with Monsieur Niepce which elicited something of that gentleman's past history. He had experienced some limited success in their joint field, having managed as early as 1816 to obtain a positive picture on paper. This, however, he was quite unable to fix. It seemed that he had taken an active part in the popularizing of lithography in Paris. A German invention in 1796, it was not seen in the French capital until 1802. There it was a trifle slow in 'catching on' but eventually in 1813 its success was definite, and it became a fashionable hobby and something of a craze. M. Niepce's part, it appeared, had been the discovery of natural stone suitable for use in this connection. After a search lasting some three or four years he had made the discovery, and scored an unequivocal success.

The correspondence between Daguerre and Niepce was from its inception conducted guardedly on either side. It took time for these two to realize that each was worthy of the other's trust. However, in 1829 the last barrier was down. They decided to join forces and work together for a single end. But they were not destined to achieve that end together. In 1833 J. Nicéphore Niepce died, and Louis Daguerre was left to finish their work

alone. Alone he went on working for another six years, until the germ of the idea became plain to him and the Daguerreotype was born.

In spite of Niepce's death, and his own six years of solitary work before the discovery was made, Louis Daguerre presented his final result to M. François Arago as the work of the partnership. As such it was presented by M. Arago to the Academy of Sciences on 18 August 1839.

Now it is as well to remark here that, as had happened before and may well happen again, these French scientists had not the monopoly of the idea for which they were seeking the key.

German inventors, British inventors, and their counterparts in many countries were on the same track. Though they did not realize it at the time they were not in pursuit of a single process, but of a number of interdependent ones, so that there was room eventually for each to contribute his part and take his share in the final triumph. However, this was not realized, and the situation was therefore competitive and potentially inflammable. This was the moment that M. Arago chose to make what many of his confrères regarded as a grave error! He anticipated his formal announcement to the Academy of Sciences by making a preliminary notice of the Daguerre success on 7 January 1839. The result of this preliminary announcement was that before the month of January was out an Englishman named Fox-Talbot gave notice to the Royal Society to claim priority in obtaining a picture on a camera and rendering it permanent.

In Paris there were groans, and cries of 'Albion perfide!' and feelings ran almost as high as they had during the Napoleonic wars. More especially was this the case when the injured parties heard that 'ce sacré Fox-Talbot' had achieved his results after experiments lasting only five years. However, the French government intervened and applied the most effective remedy for injured feelings in its power. Conditionally upon Daguerre disclosing the secrets of his process to the Academy of Sciences, in order that the government might publish them, he was assigned by law an annuity of six thousand francs. To the heirs of M. Nicéphore Niepce went an annuity of four thousand francs.

When the tumult died down and the dust cleared away a further discovery was made. The invention of Daguerre and Niepce was simply a by-path in the maze of photographic evolution. Its chief importance was the stimulus it gave to the work. The Daguerreotype was a picture taken direct on to a metal plate. Fox-Talbot had produced the first negative! So if you should at any time be asked, 'Whose invention gave the coup de grâce to profilism?', the correct answer is not Daguerre but Fox-Talbot.

Appendix: Minor Profilists and Silhouettists[1]

For the abbreviations, see p. 19. See also pp. 17–18.

ADOLPHE
G PC BP

1830. A French émigré who settled in Brighton and practised at addresses in St James's Street and East Street. He can hardly be said to have used colour, since his work is usually in one colour only, green. As a glass-painter, in which method his work is comparatively rare, he painted on convex glass and used a wax backing. A sound draughtsman with a good firm line, his work is usually signed under the bust. He specialized in painting bust portraits of a whole family on one card.

ALDOUS

1824. 15 Great Russell Street, London. Lithographed silhouettes.

ALLPORT
CUT BRO

1830. Used olive-green paper.

AMES, MRS
G BP ITIN

1785. 6 Ball Street, Birmingham. Her prices were reasonable and her work sound, without being exceptional. She was a frequent visitor to Bath for the season.

ARTISTS
PC BP

1833. 431 Oxford Street and 84 Farringdon Street, London.

ATKINSON, F.
PC CUT BP FL
GRO

1790. Windsor. Advertised as profilist to the royal family, and cut a group of George III, his seven sons and two sons-in-law.

ATKINSON, G.
PC BP

40 Old Steine, Brighton. Son of the above. Painted very much in the manner of Bullock of the Liverpool Museum. Took a portrait of George III and advertised as profilist to His Majesty and the royal family.

AYRER,
GEO. FREDK.

1768. From Lausanne. Said to have worked here.

BALEUHAM
G ITIN

1820.

[1] For Augustine Edouart, see pp, 93–105.

BANNISTER
CUT

1850. Label.

BARBER, MASTER
aged ten
CUT

Exhibited at the 1851 Exhibition.

BARBER, C. L.
CUT

1821. Advertised as 'Schier Chiratomist to His Majesty'.

BARRETS
CUT BRO FL

1840. 122 and 248 Holborn Bars, London.

BARRETT
PC BP

1799. Exeter.

BARRETT, MRS
G

BEAUMONT
PC CUT FL GRO

1840. Cheltenham. One hesitates to call him a silhouettist but nevertheless he was, and one on whom the great Augustin Edouart would have poured scorn had they ever met, for he broke that dictator's every rule [68]. His best known work is a portrait of the Awdry sisters taken at Lund House near Milksham in 1844. In this the ringleted, corseted, crinolined sisters, one seated at a tripod table, a book in her lap, the other standing protectively behind her, achieve a harmony of design which Edouart, master cutter though he was, never equalled. But their dresses are painted in brown, and the folds on the crinoline skilfully indicated; their collars flecked in with touches of white, and the lace at their wrists similarly treated. The book on the knee and the one on the table have covers of dim and reticent red. The rule against internal decoration has been flouted, and the result is a composition of softness which, if he were able to appreciate it, must prove the law-giver's despair.

BETTS
CUT BRO

1847.

BINGHAM, G.
COMP BP JM

1810. Near the Infirmary, Manchester.

BLACKBURN, J.

1850. King Street, Manchester.

BLACKBURN, W.

1850. 303 Oxford Street, London.

BRISTOW, Mrs
PC CUT COL

1840. Hackney.

BROCAS, JAMES
BP FL

1778. Dublin.

BRUCE, L.

1820. Farringdon Street, London, and 3 Somerset Place, Brighton. He painted profiles of William IV, Lord John Russell and other notabilities which were subsequently engraved and exhibited. There is, however, no evidence that he set up in professional practice as a profilist.

BULLOCK, W.
PC BP

First quarter of nineteenth century. Took profiles with Chretien's Patent Physiognotrace at the Liverpool Museum (see also under 'Methods and Machines', p. 30).

BURT, ALBIN R.
CUT

First quarter of nineteenth century. Painter and cutter. Label.

BUTTERWORTH, JOHN
COMP BP

1790. Kirkgate, Leeds. Produced some competent portraiture without being notably prolific.

CAMPBELL
PC BRO BP

1820. Painted red-brown profiles, very much in the school of Foster and Jeffreson.

CATCHPOLE
CUT

1820. Painter and cutter.

CHAPMAN, C. W.
PC BRO BP FL

1830. 59 Oxford Street, London [73].

CHENEY
PC CUT BP

First quarter of nineteenth century. Banbury. A specimen of his work may be found in the Wellesley Book.

CHICKFIELD, Mrs
CUT BP FL

1833. Market Place, Norwich.

CHINE, S.

1790. Painter, Banbury.

CLARKE, W.
COMP BP ITIN

1781. This artist presents something of a problem. He was essentially an itinerant having none but temporary addresses. He worked in the north, chiefly in and around Durham. He had a bold, vigorous and distinctive style. If judged solely by his style and the opportunities for picturesque portraiture which his

early date permitted he might be considered suitable for inclusion among the elect.

On the other hand, his method was clearly cheeseparing. Armed with squares of card prepared with a thin coating of plaster of Paris, he took likenesses wherever a sitter was to be found, delivered them unframed, collected the cash and pressed on. Specimens of his work are to be found, recognizable by their spirited demand for attention and the rough, uneven composition on which they are painted. They have a strong initial attraction, but will not bear close examination. They will be set in unorthodox rectangular frames, usually gilded. His sitters were clearly satisfied with the transaction, for it seems likely that the cost of framing exceeded that of portraiture. This statement is necessarily conjectural since no record of his scale of charges has so far come to light. If one ever does, it may lend support to the theory that a happy-go-lucky temperament did little to fill his pocket. In consequence he was unable to improve his method and we in turn are deprived of a potentially significant artist.

COMBES
CUT

Derby.

COOMBE
FL

1833.

COOPER
PC BRO

1833. His paintings on card were red-brown as well as bronzed.

CROWHURST,
GEORGE
BRO COL BP FL

1832. 40 Old Steine, Brighton. Painted portraits of the type popular at the time with black faces, grey and white dresses and jewellery picked out in gold.

DAY, T. F.

1844. Newington Butts, London.

DEMPSEY, JOHN
PC CUT BRO
COL BP FL
JM ITIN

Here is an artist who, in severe contrast with those of one method, used a number of methods, mixed them, and rang the changes on them indefinitely. In his bust portraits and full-lengths the subject is usually cut. The cutting is then over-painted, frequently in pale grey. Bronzing accentuates jewellery if any is worn; otherwise it may be used heavily on hair, features or dress, not according to formula but as dictated by the mood of the moment [72].

His jewellery miniatures were never cut but painted direct upon ivory, and differed from those of his competitors in that they frequently represented full-length figures. He appears to have been an admirer of the graceful dresses sweeping the ground which were worn by early Victorian ladies, and they frequently appear decorating various small boxes. Tobacco boxes seem to have been popular as a setting for them, for no very esoteric reason.

His work, while never aspiring to the heights reached by the profilists of the previous century, was above the average for his time. Consequently it is a surprise to find him masquerading in the guise of a price-cutter! He announces 'Likenesses in shade 3d, Bronzed 6d, Coloured 1s 6d'. One wonders how he made a living. (Note the 'Likenesses in Shade'. He does not use the new-fangled word 'silhouette' in deference to Edouart. It appears that the two men were in constant competition, and that there was antagonism between them.) However much his prices may argue the contrary, he was by no means ashamed of his work, and his initials 'J. D.' may usually be found boldly displayed beneath the portrait's bust-line, considerably larger in size than, for example, that of Miers.

DIXON, M.
PC CUT BRO
COL BP JM

1820. Bath. A pair of portraits of an unknown lady and gentleman in the Victoria and Albert Museum collection are typical of this artist's work. He painted over the cut-out bust likeness using the grey-and-white contrast so popular at the time. Bronzing was employed sparingly, and the total effect was pleasingly unpretentious. Below the bust-line is a scroll containing his signature DIXON BATH in small capital letters.

DRISCOLL
PC BP GRO

1830. Dublin. A good portraitist, but better known for his genre pictures of Dublin life. Street scenes with recognizable backgrounds before which are recorded moments which have seized his imagination [69].

FARTHING
G PC BP JM

First quarter of nineteenth century. 12 Cheapside, London. He was primarily a glass-painter but also painted on paper and card. He advertised jewellery miniatures but made no mention of composition. His work is fine but he could hardly have been prolific, since likenesses by him are extremely rare.

III

FRIEND, ROBERT
PC BP

1800. Tunbridge Wells. A painter with two distinct styles, probably prompted by the appearance of the sitter. An elderly gentleman received his severely restrained treatment in which there was no vestige of flattery. A young and attractive woman had flowers and feathers and lace showered upon her, to leave no doubt that she was indeed delectable. Mr Friend did this well, and his portraits of good-looking young women are very fetching.

Much of his work bears a simple signature, and he was probably an amateur for some considerable time. Eventually he became a professional and graced his work with a trade label.

GAPP, J.
CUT BP FL

1830. Chain Pier, Brighton. A distinctly pedestrian silhouettist, he could never attempt work which required lightness of treatment. He has one touching little characteristic: the sleeves of his sitters come to a point on either side of the wrist. This shows a total disregard for the current fashion. It seems to be an unsuccessful attempt to make hands appear like flowers, bursting from the bud.

GILLESPIE, J. H.
PC CUT BRO
COL BP

1790. Worked in London, Liverpool and Edinburgh. Many of his profiles are painted direct, but occasionally he cut the portrait first and afterwards over-painted. Bronzing when used was applied lightly. He worked here until 1820, when he went to Nova Scotia.

GODFREY, W. F.
G PC BRO
COL BP JM

1805. An itinerant profilist who confined his travelling to the West Country. While he was not limited to one method, he is best known for his portraits on glass which are painted in a very competent manner. His likenesses on ivory for setting in jewellery pieces were very popular. He had a lengthy and explanatory trade label.

GORDON, A.
PC BP

Another West Country profilist, though neither as competent nor as prolific as Godfrey. He had his headquarters for some while at Taunton.

GREGORY, A.
PC BP FL

1810–25. 32 Burlington Arcade, London. Advertised as a profilist, but does not appear to have been very much sought after.

GUEST, T.

1795. Painted profiles on paper and card but was principally a painter of coloured miniatures. Exhibited at the Royal Academy.

HAINES, F.
CUT

Tower-keeper of the Chain Pier, Brighton, who cut silhouettes. His work was slightly better than that of his colleague, J. Gapp.

HALLAM, J.
CUT

1820. An example of his work is to be seen in the Victoria and Albert Museum collection, a cut-out likeness of an elderly lady, mounted on card and not of very good quality.

HANCOCK
PC BP

1810–1820. Bristol. Practised as a profilist, but was principally employed as a drawing master.

HANKES
CUT BRO

English child prodigy. In 1828 he went to America. There he joined forces with Master Hubard (q.v.) who had arrived in New York four years earlier.

HARRADENE,
RICHARD
PC BP

B. 1756, D. 1838. A Cambridge drawing master, publisher of Oxford and Cambridge views. Painted profiles in blue-grey. There is an example in the Victoria and Albert Museum collection dated 1802. He had a trade label.

HARRIS, T.
CUT BRO BP

1827. Cut a portrait of William IV.

HERVÉ, A.
PC CUT BRO
FL JM

1840. 145 Strand, London. Portraits usually painted in grey, lined in black, with light bronzing.

HERVÉ, CHARLES
CUT BRO

Since the early days of collecting one has been used to hearing the three profilist members of the Hervé family described as brothers. A gap of some thirty years between the activities of Henry (see page 71) and Charles throws some doubt on that relationship. Henry was the leading light, partly because he was first on the scene, but more especially because of his versatility and skill in all the standard methods.

Charles, however, did not lag far behind him. While others, seemingly hypnotized by the beauty of bronze were, to paraphrase Sir Henry Wood 'splashing it on regardless', he demonstrated his artistry by using it sparingly to indicate light falling on the figure. A single-figure composition by him has recently come to light which demonstrates this. On a monochrome study of a handsome interior lit by tall windows is imposed the figure of a young girl with a harp [F]. The economic handling of a problem of light which could have easily been made theatrical shows that the period of decadence was not without some genuine delights.

An important item in Charles Hervé's repertoire was the coloured miniature. An example of his work in this capacity is illustrated in plate 70, 'Portrait of Miss Croker after the original painting by Sir Thomas Lawrence'.

The Rt. Hon. John Wilson Croker, M.P., was a political figure of considerable significance, and a friend of Lawrence to whom he sat for his own portrait, which had an added success when reproduced in an admirable mezzotint by Samuel Cousins.

The Miss Croker of Charles Hervé's miniature was born Rosamund Hester Elizabeth Pennell, daughter of William Pennell. She was John Croker's sister-in-law and he adopted her as his daughter. The miniature appears to have caught and kept for us the full feeling of the Lawrence original which is now in America at the Buffalo Art Gallery.

Charles Hervé exhibited twenty-seven miniature portraits at the Royal Academy between 1828 and 1858. He worked at the following addresses, all in London:

(?)	143 Strand
1828	21 Paradise Place
1835	172 Oxford Street
1841	248 Regent Street
1847	193 Oxford Street
1848	392 Strand
1855	210 Oxford Street
1858	256 Oxford Street

HILL
CUT

398 Oxford Street, London. See plate 71.

HODGSON, Mr

1774. 33 Tavistock Street, Covent Garden, London. He is recorded by Mrs Nevill Jackson but no work by him has ever come my way.

HOLLAND, WM.
LANGFORD
G BP
SILK BACKING

1777–87. Profilist in Dublin. Advertised 'Profiles à la Marlborough' [sic] at prices of one to five guineas. Standard of work by no means as high as his English contemporaries.

HOWIE, J.
PC BP

There is a portrait of a gentleman by him in the Victoria and Albert Museum collection. Very competent work. His address was 65 Princes Street, Edinburgh.

HUBARD, MASTER
CUT COL

The juvenile prodigy of profilism. Born in 1807, he cut his first portrait at the age of twelve. Advertised as the 'little boy with a pair of common scissors'. He took portraits when he went to America in 1824 of the President and Mrs Franklin Pierce. He was still in his teens, and most of his work at that age had little sign of quality. Its public appeal lay in the youth and speed of the operator. Later, with some twenty years' accumulated experience behind him, no longer Master Hubard but promoted to being the Hubard Gallery, it was a different story. Work of his at the later date can still be faulted, but he was occasionally capable of producing a pastoral scene containing figures, birds and animals, in a painted background full of mellow colour, good enough to satisfy the most choosy collector.

In 1862 he met his death as a member of the Confederate army while filling a shell at Richmond, Virginia. (See also Hankes.)

JEFFRESON
PC CUT BRO
COL BP ITIN

An early nineteenth-century cutter whose work, at first sight, may easily be mistaken for that of his contemporary Foster. Closer examination reveals marked differences. His London address was 4 New Street, Strand. His work was good considering his extremely moderate charges.

JOHNSON, T.
G

1785. Harrogate. A painter on flat glass who practised in Harrogate for a comparatively short spell.

JONES, T.
G

1785. Some examples backed with darkish green wax.

JONES, T. H.

1800. 4 Wells Street, Oxford Street, London. Advertised as 'Artist and Drawing Master from the Royal Academy, London'.

LLOYD, A. G.
CUT BRO BP FL

Second half of nineteenth century. Chain Pier, Brighton.

LOW
PC BP

1840–50. Worked in Dublin and Belfast.

MANNERS, W. H.

1830. 286 High Holborn, London. Exhibitor at the Royal Academy.

MARDEN, F.
PC BRO BP

1820.

H★

MARTIN, WM. 1825. Stockport. Painter.

MASON, W. St Mary's Passage, Cambridge. Described himself as profile
PC BRO BP painter to H.R.H. the Duke of Sussex and displayed the Royal
Arms on his trade label.

MERRYWEATHER 1870.
CUT BRO

METFORD, Naturalized American 1834. Practised here 1844–90.
SAM MILES 1800. An itinerant profilist, who cut bust and full-length por-
traits enlivened with bronzing.

MILLINGTON, A nineteenth-century machine worker. 205 High Holborn,
J. H. London. Very low prices.
PC BRO BP

MITCHELL, J. S. 17 Union Street, Bath. Also 40 Strand, London.
CUT BRO
BP ON IVORY

NEVILLE, J. 1830. Pool Lane, Brighton. Also 393 Oxford Street, London.
PC BP FL

OLDHAM, JOHN 1779–1807. Invented the Eidograph, a machine for taking pro-
files, which he priced at eleven shillings and fourpence halfpenny.

O'REILLY Irish glass-painter, but principally a drawing master.
G BP

PASKIN Colchester. He appears to have been resident there and not to
G PC COL have travelled. Good work. Label.
BP JM

PELHAM, T. 1830–40. 15 King's Mead Terrace, Bath. Also 21 Elizabeth
G PC BP Street, Islington, and 8 Buckingham Place, London. Advertised
as 'Miniature Painter to H.R.H. Princess Augusta'. Exhibited
miniature portraits at the Royal Academy between 1832 and
1836. Trade label.

PERCIVAL 1840. He made machine-cut silhouettes at 7 Grafton Street,
Dublin, and advertised 'Portrait frame and glass for One
shilling in One minute'.

PLATER, MRS 1790. She advertised that she painted profiles on porcelain ovals.
PC BP Whether they were subsequently glazed and fired she does not
ON PORCELAIN say. Her trade label requires a five-minute sitting and quotes

OVALS

prices as from six to ten shillings. The address given is Bull Ring, Kidderminster.

PROSSER, M. R.

1791. Whether this artist was a professional profilist offering his services to the general public is not known but it seems unlikely he was. One work has brought him to our attention, and it may be seen in the Victoria and Albert Museum collection. It is an *églomisé* portrait of George III and Queen Charlotte, somewhat unusual in that the background is in black instead of gold, entailing a reversal in the actual portraits.

RIDER AND
BAZING
G BP JM

1800. 408 Strand, London. L. T. Rider seems to have been the moving spirit in this enterprise, and little is known either of Bazing or his work. Years ago as a young collector, an *églomisé* portrait bearing their trade label was offered to me. It was of fine quality, but being too inexperienced to appreciate its rarity I allowed it to escape. Needless to say, nothing comparable by this firm has since come my way. Collecting has its moments of lasting sadness!

RISSO, SIGNOR
PC BP ITIN

1776. An Italian itinerant, who advertised that he had visited most of the towns in this country. Despite this, very few examples of his work have survived, and none has come my way. He is known to have visited towns in the North Country, usually industrial cities rather than spas.

ROGERS
G BP

c. 1815. Millbay, Plymouth. A mediocre glass-painter, who backed his portraits with composition or silk. An example may be seen in the Victoria and Albert Museum collection.

SANDHEGAN,
M. R.
G PC BP JM

c. 1810. Marlborough Street, Dublin. He was probably capable of good work, but only poor examples have come my way. His label might adorn any collection for its pleasantly sentimental, 'Dans l'absence du reél, l'ombre me content.'

SEVILLE, F. W.
CUT ITIN

1820. A freehand cutter who worked mainly in the north of England and was clearly popular, since his shades appear quite frequently.

SMYTH,
MRS EDWARD
PC BRO BP

1836. She practised at 40 Strand, London, and produced work of no particular distinction.

THOMAS, R.

83 Long Acre, London. Machine-made likenesses.

TREWINNYARD, J.
COMP PC BP
His label on a portrait of an elderly lady in an oval pearwood frame, apparently circa 1795:

> 'Profiles of every Description taken in the most correct manner on IVORY, GLASS, COMPOSITION or CARD, and Cut Out by J. TREWINNYARD, No 40, Strand. Those on Ivory are in the most approved Stile ever yet offered to the Public, as the Features and Complexion are obtained as well as a correct outline.
>
> Miniatures painted by Mrs A. Trewinnyard Warranted Likenesses and finished in the first Stile from 3 to 5 guineas. Cheap and Elegant Frames and Glasses.'

Mrs A. Trewinnyard exhibited at the Royal Academy in 1802 a 'Portrait of Master Browne'.

WALKER, G.
CUT BRO
1820. A stencilled label accompanies his work, giving his address as 43 Lord Street, Liverpool. His likenesses are, at best, mediocre.

WALKER, J.
PC BP
1795. Trowbridge.

WATKIN
PC CUT BRO COL
1800. Windsor and Bath. A rather more than average painter. A portrait of William IV taken while he was Duke of Clarence may be seen in the Victoria and Albert Museum collection.

WEST
PC COL BP JM
An itinerant profilist slightly out of the run-of-the-mill in as much as he advertised that he required two sittings (a daring requirement when so many of his competitors guaranteed a sitting of less than one minute), though he qualified the requirement with the proviso that the sittings would be short. As his principal speciality he offered to paint coloured miniatures, his price for them being two to six guineas each.

He took the profiles with the aid of a portable machine of which his advertisement speaks very highly! He charged five shillings for them in black, ten shillings and sixpence in colour; one guinea and upwards on wood in colour. He also offered to reduce them to the size for rings, lockets and brooches. He is among the artists whose work is very rare.

WHEELER
1794. Windsor. His trade label advertises that his 'portraits on glass will not wash off', which is at least original, and he offers

'A striking likeness of the King for sale' without claiming that the King sat to him for it. His prices are hardly those of a royal portraitist of the time.

WOODHOUSE, J. 1820. Blackett Street, Newcastle-on-Tyne. Painter of full-length
G FL portraits and small groups on glass. They are often lifeless and usually over-framed in rosewood.

Bibliography

Bury, Adrian, *Thomas Rowlandson*, Avalon Press, London, 1949.

Coke, Desmond, *The Art of Silhouette*, Martin Secker, London, 1913.

Coke, Desmond, *Confessions of an Incurable Collector*, Chapman and Hall, London, 1928.

Dictionary of National Biography.

Edouart, Augustin, *Treatise on Silhouettes*, Longman, London, 1835.

Encyclopaedia Britannica.

Gardiner, William, *Autobiography*, 1814.

Gray, J. M., *James and William Tassie*, Patterson, Edinburgh, 1894.

Hasted, J. E., *Unsuccessful Ladies*, Robert Hale, London, 1950.

Hickman, Peggy, *Silhouettes*, Cassell, London, 1968.

Jackson, E. Nevill, *History of Silhouettes*, Connoisseur, London, 1911.

Jackson, E. Nevill, *Ancestors in Silhouette*, Bodley Head, London, 1921.

Jackson, E. Nevill, *Silhouette*, Methuen, London, 1938.

Lavater, Johann Caspar, *Essays on Physiognomy* (1789), trans., London.

Laver, James, *English Costume in the Eighteenth Century*, A. and C. Black, London, 1931.

Mankowitz, Wolf, *Wedgwood*, Batsford, London, 1953.

May, L. Morgan, *A Master of Silhouette*, Westminster Press, limited edition, Philadelphia, 1938.

Phillips, Phillip A. S., *John OBrisset*, Batsford, London, 1931.

Phillips, H. H. (ed.), *Georgian Scrapbook*, Werner Laurie, London, 1950.

Reilly, D. R., *Portrait Waxes*, Batsford, London, 1953.

Royal Academy, catalogues of Summer Exhibitions, 1794–1816.

Sermoneta, the Duchess of, *The Locks of Norbury*, John Murray, London, 1940.

Tassie, James, *A Descriptive Catalogue of Engraved Gems*, 1791.

The Wellesley Book of One Hundred Silhouettes, privately printed, limited edition.

Woodiwiss, John, *British Silhouettists*, Country Life, London, 1965.

Index

INDEX

Betham, Mary, miniaturist, author of *Biographical Dictionary of Celebrated Women*, 82

Betham, William, author of *Genealogical Table of Sovereigns of the World*, 82

Betts, minor profilist, 108

Bibliothèque Nationale, Edouarts in, 96

Bingham, G., minor profilist, 108

Birmingham Gazette, Mrs Hudson advertises in, 37

Bishops' portraits, by Edouart, 101

Black and sepia contrasts (J. Betham), 79

Black paper likenesses as I. Beetham's early work, 38-9

'Black Spornbergs', 36

Blackburn, J., minor profilist, 108

Blackburn, W., minor profilist, 108

Blairman, Messrs. H. and Sons, 88

Bordeaux, le Duc de, Edouart portrays, 96

Bouttats' signature (*verre églomisé*), 78

'Bow at neck' as Harrington signature, 53

Brass, stamped, for frames, 29, 34

Brass, profiles cut from, 30

Bridge Ward Coffee House, 35

Bristol porcelain, with shadow portraiture, 89

Bristow, Mrs, minor profilist, 109

Brocas, James, minor profilist, 109

Bronzing, 29, 69, 71, 93; *and see* Field

Brooks, Mr, advertises 'likeness machine', 31-2

Brough, Lionel, 86; on Phil May, 86

Bruce, George, 21, 67; in partnership with Houghton, 60, 67; resemblances with Miers, 76; gentleman by, Pl. 40

Bruce, L., minor profilist, 109

Bull, Mrs, 21, 68, Pl. 43; paucity of signatures and labels of, 76; method of hair-painting of, 76; similarities with Charles, 68

Bullock, W., minor profilist, 109; as user of Physiognotrace, 30; a comparison with G. Atkinson, 107

Buncombe, John, 21, 68; attributions to, 76; army portraits and work generally, 68-9, 87, 88, 94; Pls. C, 39, 42; accuracy of, 80; fakes and imitations of, 80; supplied work unframed, 14, 68

Burney, Fanny, 90

Burns, Robert, Houghton portrays, 67

Burt, Albin R., minor profilist, 109

Butterworth, John, minor profilist, 109

Caledonian Mercury, The, 63

Campbell (red-brown profiles), minor profilist, 109

Caroline, Queen, OBrisset portrays, 24

Catchpole, minor profilist, 109

Ceramic portraiture: bas-relief, 24-5; shadow portraits on porcelain, *see* Porcelain

Chamberlain's Worcester porcelain, George III shadow portraits on, 89

Champion, Richard, Bristol porcelain-factory of, and shadow-portrait mugs, 89

Chapman, C. W., minor profilist, 109, Pl. 73

Charles, A., 20, 61, Pl. 32; appointed as likeness painter to Prince of Wales, 62; hair-painting style of, 61-2, 76; jewellery pieces by, 92; rare label and signature of, 61; technique of, huge total of portraits by, 35

Charles I, OBrisset portrays, 26, Pl. 1

Charles X of France, Edouart portrays, 96

Charlotte, Princess, wax portrait of, by Peter Rouw, 24, Pl. 2

Charlotte, Queen: appoints Foster as miniature painter, 63; Charles portrays, 62; Hintor Gibbs's uncompromising portrait of, 72; Rosenberg as page to, 63; portrayed with George III and six daughters, by Rought, 71; *see also* George III

Chaucer, Wedgwood portrait of, 24

Cheney, minor profilist, 109

Chickfield, Mrs, minor profilist, 109

Chilcot, Henry (Bath), goldsmith and jeweller, 37

Child portraiture, 60, Pls. 30a, b, 50; *see also* East, S. A.

Chine, S., minor profilist, 109

Chrétien, G. L., and his Physiognotrace, 30, 109

Christie Collection, *see* 14

Clarke, W., minor profilist, 109-10

Clay, Henry, Edouart portrays, 101

Clay, Robert, Foster portrays, Pl. 35

Clothing, pictorial qualities of, 33

Coalport porcelain, with shadow portraits, 89-90

Coke, Desmond, collector and author, also bequest of, to Victoria and Albert Museum, 35, 50, 53, 66, 76-7, 81, 87, 88, 90, 91; Rowlandsons collected by, 87

Cole, Nicholas, T. London portrays, Pl. 51

Collecting: how to begin, 76-7; some alternative objects for, 84-92

124

INDEX

Godden Collection, *see* 15
Godfrey, W. F., minor profilist, 112
Gordon, A., minor profilist, 112
Gossett, Isaac, ceramic and wax modeller, 24; composition improved by, 24; working for Wedgwood, 24
Gotha, *see* Germany
Gray, F. A., painted hand-screens by, 84, 85, Pl. 56
Gray, Thomas, informed of Joliffe's 'profiles taken by candle', 29
Greek shadow portraits, 28
Gregory, A., minor profilist, 112
Guest, T., minor portraitist, 112

Hackwood, William, principal modeller to Wedgwood, 24
Hagbolt, T., wax modeller, 24
Haines, F., minor profilist, 113
Hair, treatments of: and attribution, 76; I. Beetham's, 79; Mrs Bull's, 68; Charles's, 61–2, 76; Field's, 98; Joliffe's, 34; W. Spornberg's, 36; style of heavily bronzed (Dempsey), 110
Hair-work: bracelets, 86; Edouart's (hair and wax models), 95; Miers's, 59; J. Smith's (with pearls), 62
Hallam, J., minor profilist, 113
Hamlet, William (father and son), 20, 47, 81, 82; George III (equestrian portrait) by father, 47, Pl. 21; painted-on-glass army officers' portraits, 47
Hancock, minor profilist, 113
Hand-screens as collector's item, *see* Gray, F. A.
Hankes, minor profilist, 113
Hardwood, profiles cut from, 30
Harradene, Richard, minor profilist, 113
Harrington, Sarah, 19, 42, 53, Pl. 15; as paper-portrait cutter, 28, 43; as first professional operator to use machine, 42; patents her 'likeness machine', 31, 43; paintings on silk and satin by, 43; as 'Profilist to the King', 42–3; as specialist in hollow-cut, 43; the 'bow at neck' aid to attribution, 53
Harris, T., minor profilist, 113
Harrison, President, Edouart portrays, 101
Hawkins' Patent Machine, 71
Haygarth, Lady Blanche, water-colour painting by, of Mrs FitzHerbert, 81
Hazlitt, William, *Table Talk* quoted, 33

Henrietta Maria, OBrisset portrays, 24, 26
Heraldry, and *verre églomisé*, 65
Hervé, Charles, minor profilist, and coloured miniatures, etc., of, 113–14, Pl. F; Mrs Croker portrayed by, 114, Pl. 70
Hervé, Henry, 21, 71, 93, 113, Pl. 47; as skilful bronzer, 71; jewellery pieces by, 71
Hesse, Landgrave of, jewels and medals of, 25
Hill, minor profilist, 114, Pl. 71
Hippisley, Sir John Coxe, Miers portrays, 51
Höchst, *see* Germany
Hodgson, Mr, minor profilist, 114
Holland, William Langford, minor profilist (silk backing), 114
'Hollow' painting, W. Spornberg's, 36
Hollow cut technique of paper cutting, 43
Holyrood Palace, Edouart's work at, 96
Horn, portraits carved in, 23; of Charles I (OBrisset), 26, Pl. 1; horn and tortoiseshell pressing as minor art, 25
Houghton, S., 20, 60: as assistant to Miers, 49, 62; in partnership with Bruce, 49, 60, 67; their trading label, 67; child portraiture by and jewellery pieces, 60, Pls. 30a, b; transmits Miers's methods to Bruce, 76; Robert Burns portrayed by, 67
Howie, J., minor profilist, 114
Hubard, Master, minor profilist and painter of pastoral scenes, 115
Hudson, Mrs, 19, 37, Pl. 10; trade label of, 37, Pl. 11

Incorporated Society of Artists, 24
Ireland, *see* Edouart
Irving, Sir Henry, *see* May, Phil
Ivory: an Isabella Beetham portrait on, 40; London's use of, 72; for jewellery miniatures (Miers, etc.), 20, 50, 51, 59; profiles cut from, 30

Jackson, E. Nevill (*see* Bibliography), 41, 43, 47, 53, 64–5, 66, 78, 88, 114; a Field landscape owned by, 85; a Watkin recorded by, 34; on Field's gold hair, 98; *see also* 15
James I, OBrisset portrays, almost full-face, 24, 26
Jasper-dip ground (Wedgwood plaques), 24
Jefferson, minor profilist, 115; similarities with Foster, 79, 115
Jewellery pieces, 29, 91–2, Pl. 58; Dempsey's, 111; Farthing's, 111; by major

127

INDEX

INDEX

Profile: as 'key to personality', 23–6; profile miniature defined, 23; taking precedence, 23–7

Profilists: major, 34–74; minor, 107–19

Prosopographus, invention of, 31

Prosser, M. R., minor profilist, 117; *verre églomisé* portrait of George III and Queen Charlotte by, 117

Punch artists, 86, 101

Pyburg, Mrs, shadow portrait of William and Mary by, 1699, 28

Quin, Dr Henry, works with Tassie on development of vitreous pastes, 25

'Raree shows', 30, 33

Rashleigh family, Beaumont portrays, Pl. 68

Raspe, Rudolf Eric, author of first *Baron Munchausen*, 25; background, appointments of, 25

Read, Mrs John (Jane Beetham, Jane Betham), 21, 42, 73, 81, 82, 93; our revised knowledge of work of, 82–3; pastoral and classical elements in work of, 73, 80; replaces profile shades by 'aquatinta likenesses', 72–3, 80, 94, Pls. 52–3; Royal Academy exhibits by, 73, 82; *see* Beetham, Betham, esp. for work before Lamb's Conduit Street studio set up

Read, John, husband of Jane Beetham, 41

Rectangular frame (*see also* Frame, papier-mâché), introduction of, 14, 29

Red Indians, Edouart portrays, 102

'Red portraits', *see* Foster, Jefferson; red against black, or 'Red Spornbergs' (W. Spornberg), 36, 78; *see also* Campbell, Cooper

Redhead, H., 20, 62, Pl. 33; paintings on glass by, compared with Lea's, 62; paucity of labels, signatures, 76; unusual use of stipple by, 62

'Redressing', reducing, of portraits, shades, 39–40, 52 seqq., 65, 66, 67, 118

Regimental officers, Edouart portrays, 101; for army portraits, *see* Buncombe, Hamlet

Rider, T. (sometimes L.T.), 21, 65–6, Pl. 41; Bazing in partnership with, 66, 77, 117; claims to have invented gold borders on convex glass, 66; and the *verre églomisé* process, 65, 77, Pl. A

Risso, Signor, minor profilist, 117

Roberts, H. P., a Joliffe sitter mistakenly considered to be artist, 78

Rogers (silk on composition backing), minor profilist, 117

Romney, George, portrays Mrs FitzHerbert, 81

Rosenberg, Carl Christian, 20, 63, 81, 82, Pls. 36, 37, 61; attributions to, 79; as H.M. Profile Painter, life of at Windsor, royal portraits by, 63; jewellery pieces by, 92; a similarity with Foster, 63

Rothschild, Nathan Mayer, Edouart portrays, 96, 101

Rought, 21, 70, 81, 82, Pl. 44

Rouse, George, a possible profilist, 35

Rouw, Peter, wax modeller, 24, Pl. 2

Rowlandson, Thomas, pastoral and genre work of, 87; only known profile by, 84, 87, Pl. G; theatrical element in, 100; 'Vauxhall Gardens', sale of, as indication of changing tastes in 1940s, 87

Royal Academy, 24, 41, 45, 73, 82

Russell, Lord John, L. Bruce portrays, 109

St Albans, Duchess of, Jane Betham portrays, 82

Sandhegan, M. R., minor profilist, 117

Satin, portraits on, 44

Schmalcalder, Charles, machine for taking likenesses patented by, 30, Pl. 5

Scott, Sir Walter, Edouart portrays, 96, 101, Pl. 66

Scrap-books, as source for collectors, 14, 68

'Seal engraver label' of Miers, 57, 59; *see* Fob-seals

Seville, F. W., minor profilist, 117

Sèvres porcelain, Mirabeau and others portrayed on, 91

Shades, shadow portraits, 23, 28; as ancient art form, 28; cutters and painters bring professional skills to, 28 seqq.

Siddons, Sarah, Miers portrays, 45, 51, 53, Pl. 25; Wellings portrays, 45

Silhouette, Etienne de, 94; first appearance here, of word 'silhouette', 94; as misused word, 94

Smart, John, miniaturist: in India, 40; instructs I. Beetham, 40

Smith, Joachim, ceramic works of, 24–5; uses flesh-pink composition, 25; portraits by, at Windsor, 25

Smith, J., of Edinburgh, 20, 62, Pl. 34; as

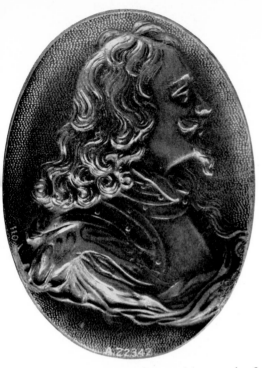

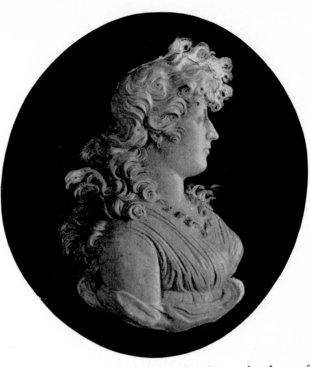

1 John OBrisset. Horn plaque with portrait of Charles I. Signed OB. (*Page* 24)

2 Wax portrait of Princess Charlotte, daughter of George IV, attributed to Peter Rouw. (*Page* 24)

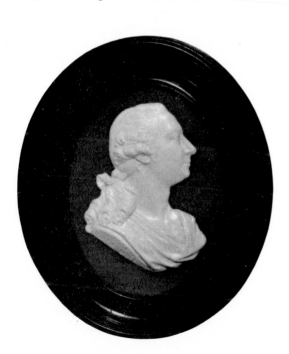

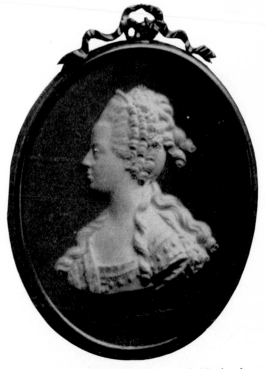

3 James Tassie. Portrait plaque of Hugh, Duke of Northumberland. (*Page* 25)

4 Wedgwood portrait plaque of Marie Antoinette. After a terra-cotta relief by Jean-Baptiste Nini 1717–1786. (*Page* 24)

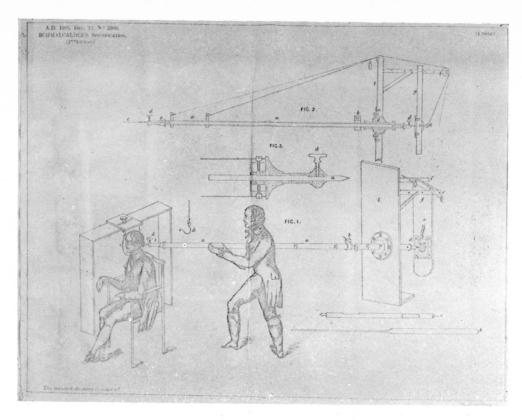

5 The ingenious device of Charles Schmalcalder of Little Newport Street, Soho, London, mathematical and optical instrument maker. It was patented in 1806. By its aid profiles could be traced and cut out. (*Page* 30)

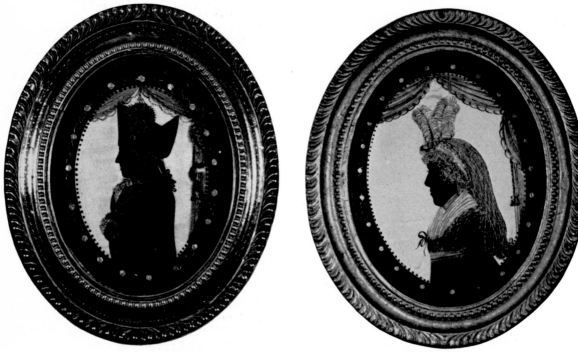

6 Joliffe. Captain Dewey. Painted on glass and backed with silk. (*Page* 34)

7 Joliffe. A lady. (*Page* 34)

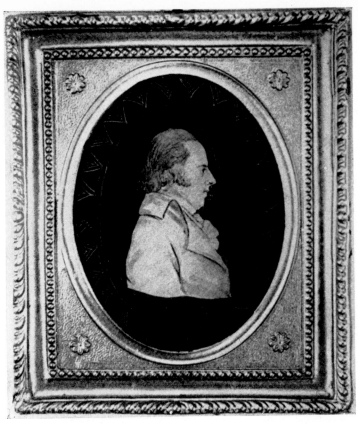

8 W. Spornberg. A gentleman, painted on glass in Venetian red against a black background and signed *W. Spornberg Invenit Bath 1793.* (*Page* 35)

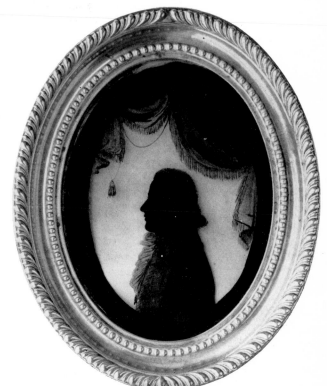

9 A rare 'Black Spornberg'. Signed on the reverse *J. Spornberg pinxt, No 2, Lilliput Alley, North Parade, Bath.* (*Page* 36)

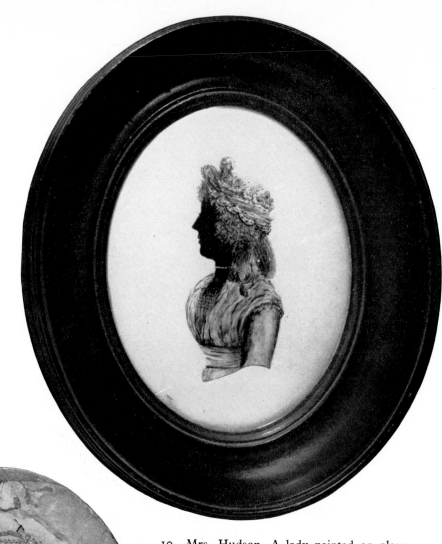

10 Mrs. Hudson. A lady painted on glass. (*Page* 37)

11 Mrs. Hudson. Her trade label. (*Page* 37)

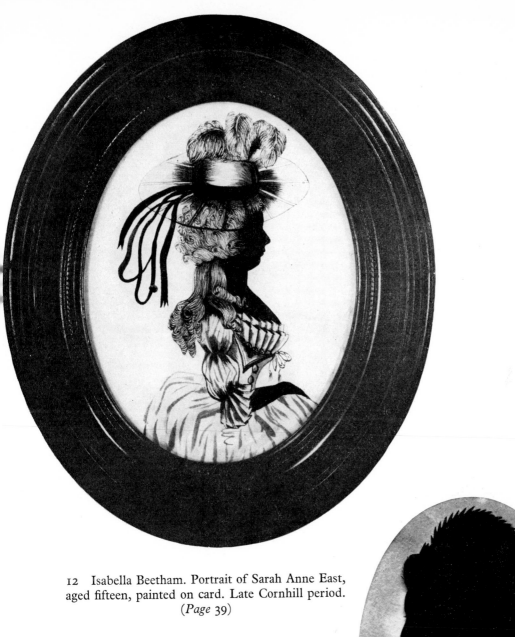

12 Isabella Beetham. Portrait of Sarah Anne East,
aged fifteen, painted on card. Late Cornhill period.
(*Page* 39)

13 Isabella Beetham. Early cut portrait with the
double curve truncation. (*Page* 38)

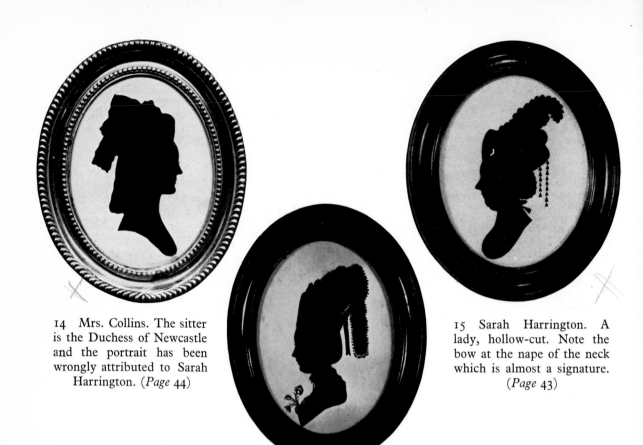

14 Mrs. Collins. The sitter is the Duchess of Newcastle and the portrait has been wrongly attributed to Sarah Harrington. (*Page* 44)

16 Mrs. Lane Kelfe. Portrait of a lady painted on paper. (*Page* 44)

15 Sarah Harrington. A lady, hollow-cut. Note the bow at the nape of the neck which is almost a signature. (*Page* 43)

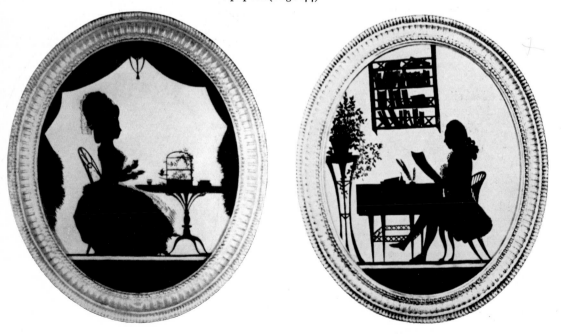

17a, b Francis Torond. A pair of single-figure compositions painted on paper. $14\frac{1}{2} \times 12\frac{1}{2}$in. (*Pages* 45, 46)

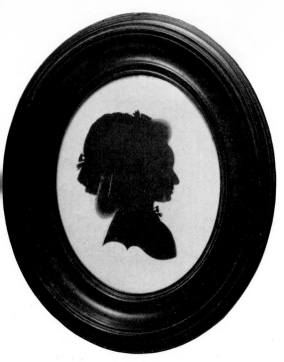

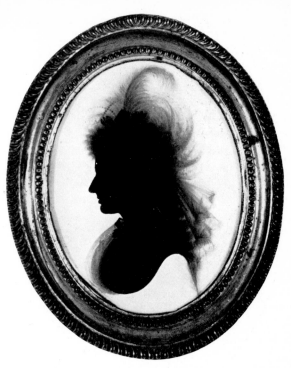

24 John Miers. One of a pair bearing his fourth
Leeds label. Probably copied from an original by
Isabella Beetham. (*Page* 48)

25 John Miers. Portrait of Sarah Siddons painted
on composition. Taken at Edinburgh in 1786. (*Pages*
49, 51, 53)

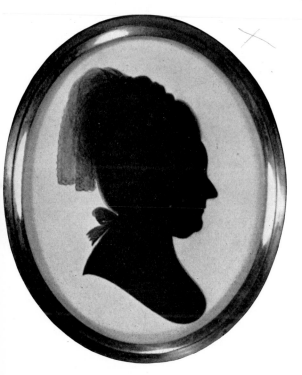

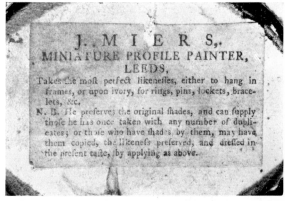

J. MIERS,
MINIATURE PROFILE PAINTER,
LEEDS,

Takes the most perfect likenesses, either to hang in
frames, or upon ivory, for rings, pins, lockets, brace-
lets, &c.
N. B. He preserves the original shades, and can supply
those he has once taken with any number of dupli-
cates; or those who have shades by them, may have
them copied, the likeness preserved, and dressed in
the present taste, by applying as above.

27 John Miers. His sixth Leeds label. Unknown to
Morgan May and the early collectors, it came to light
in the 1940's. It contains his earliest reference to
jewellery miniatures. (*Page* 55)

26 John Miers. Portrait of a lady. Copied from an
original by Sarah Harrington. This has his fourth
London label. (*Page* 53)

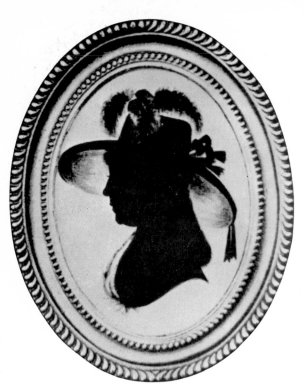

28 J. Thomason of Dublin. Portrait of a lady, painted on composition. (*Page* 61)

29 John Patey. A gentleman, painted on composition. (*Page* 60)

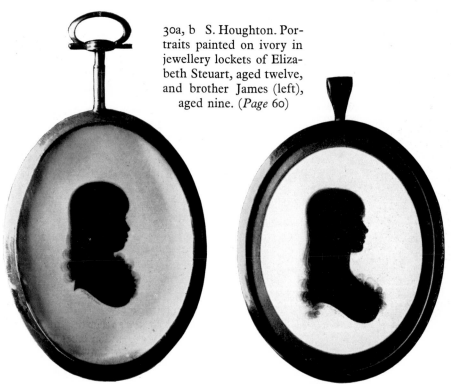

30a, b S. Houghton. Portraits painted on ivory in jewellery lockets of Elizabeth Steuart, aged twelve, and brother James (left), aged nine. (*Page* 60)

31 Mrs. Lightfoot. A lady, painted on composition. (*Page* 61)

32 A. Charles. Portrait of a gentleman, painted on glass. (*Page* 62)

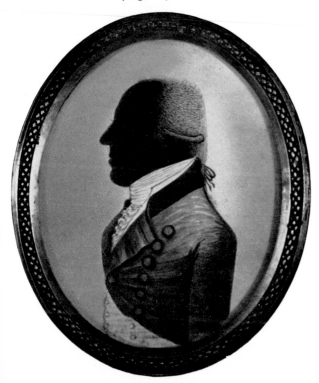

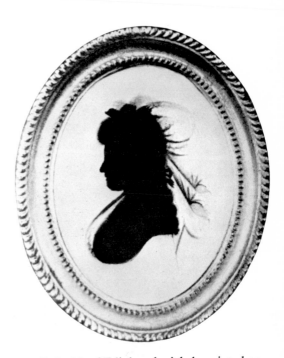

33 H. Redhead. Portrait of a gentleman painted on glass by this very rare artist. (*Page* 62)

34 J. Smith of Edinburgh. A lady painted on composition. (*Page* 62)

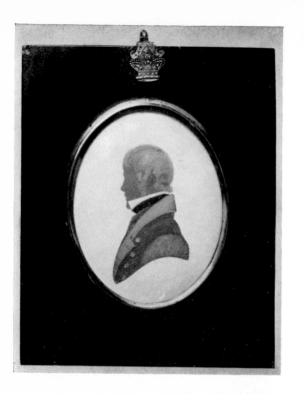
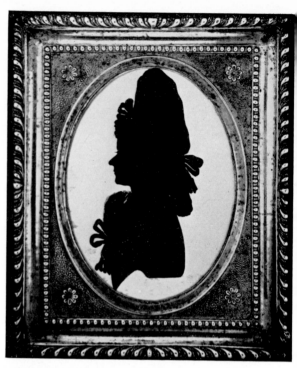
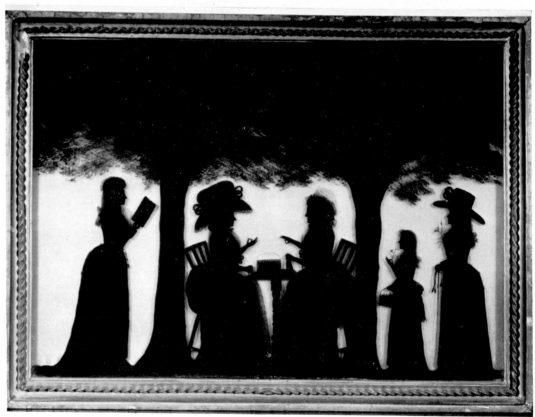

38 W. J. Phelps. Three likenesses in his best manner. The lady's dress has a belt of apple-green. The gentlemen wears a coat of rich blue with gold buttons. The young man has a brilliant primrose-coloured waistcoat. (*Page* 65)

OPPOSITE 35 Edward Ward Foster. Portrait of Robert Clay, painted on card and dated 1833. On the hanger, note the scroll above the crown on which Foster's name is inscribed. (*Page* 63)

36 Carl Christian Rosenberg. A lady, painted on glass. Note the distinctive base line. (*Page* 63 *and plate* 61)

37 Carl Christian Rosenberg. A royal group. The two central figures are said to be Queen Charlotte and Mrs. Delany, supported by three of the princesses. The companion group is in Windsor Castle. 18 × 25in. (*Page* 63 *and plate* 61)

39 John Buncombe of Newport, Isle of Wight. Four officers painted on paper, the uniforms in colour. (*Pages* 69, 80 *and see plates* C *and* 42)

40 George Bruce. A gentleman painted on composition. (*Page 67*)

41 T. Rider. A lady painted on glass. This likeness bears the label announcing the offer of *verre églomisé* portraiture. (*Page 65*)

42 John Buncombe. An officer of the 64th regiment, the uniform painted in colour. (*Page 68 and see plate* 39)

43 Mrs. Bull. Portrait of a lady by this rare artist. (*Page 68*)

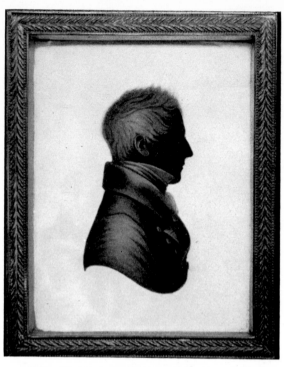

44 W. Rought of Oxford. An academic, painted on glass, composition backing. (*Page* 71)

45 John Field. A gentleman, painted on composition and bronzed. (*Page* 69 *and see plate* 59)

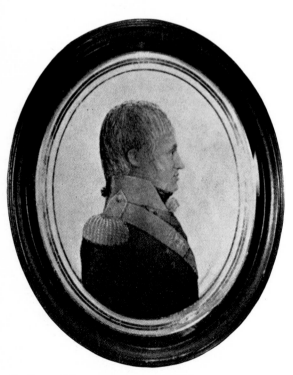

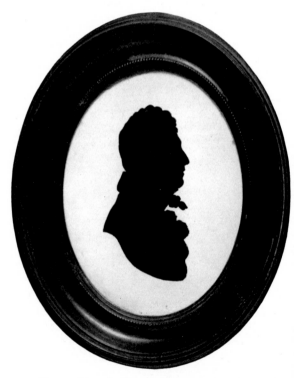

46 Lea of Portsmouth. A naval officer painted on glass with a composition backing. (*Page* 69)

47 Henry Hervé. A gentleman, painted on glass and backed with pink wax. (*Page* 71)

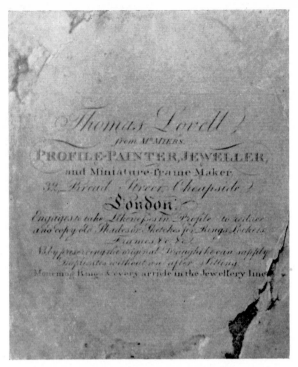

48 Thomas Lovell. His trade label. (*Page* 72)

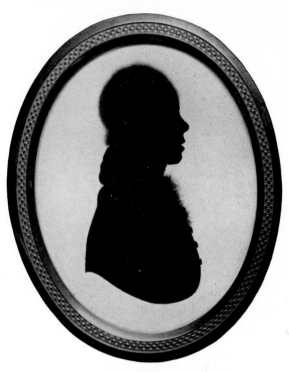

49 Thomas Lovell. A gentleman painted on composition. (*Page* 72)

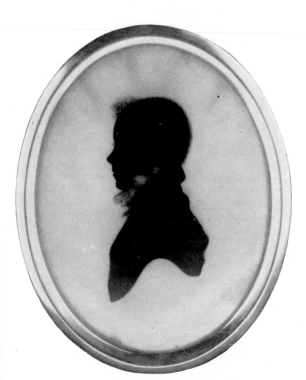

50 Hintor Gibbs. A boy, painted on glass and backed with wax. (*Page* 72)

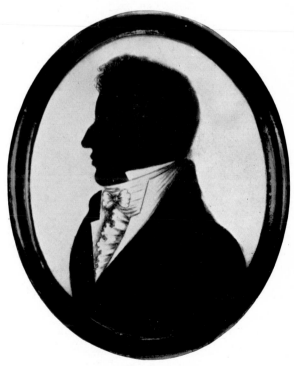

51 T. London. Portrait of Nicholas Cole. Painted on ivory. (*Page* 72)

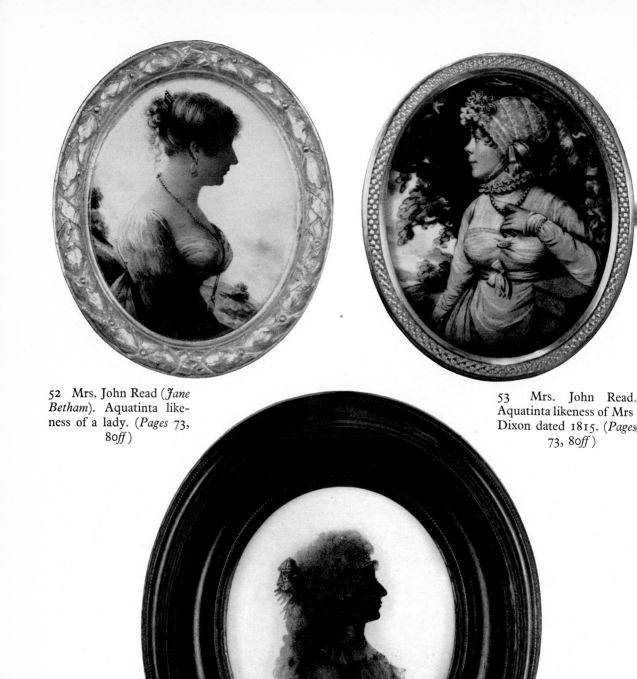

52 Mrs. John Read (*Jane Betham*). Aquatinta likeness of a lady. (*Pages* 73, 80*ff*)

53 Mrs. John Read. Aquatinta likeness of Mrs Dixon dated 1815. (*Pages* 73, 80*ff*)

54 Isabella Beetham. Portrait of a lady painted on glass. Compare with the likeness of Sarah

Anne East (*plate* 12). They are both examples of the 'Beetham manner'. (*Page* 40)

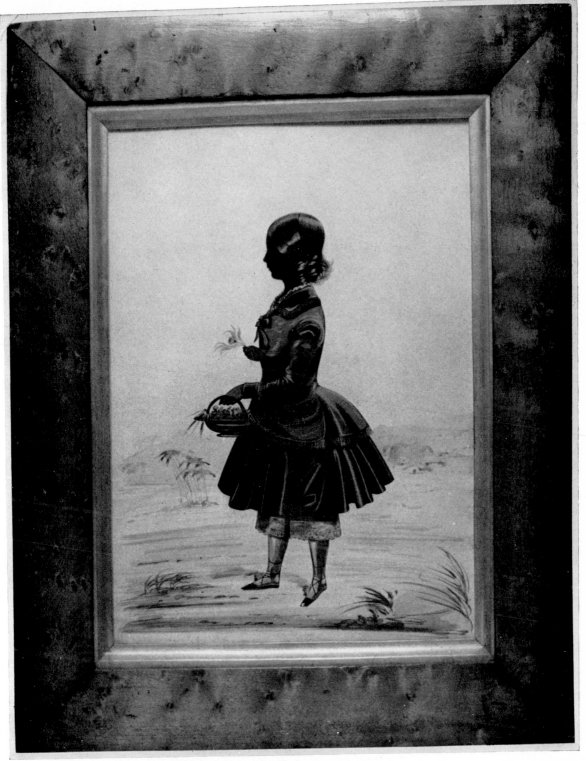

55 Frederick Frith. 'The girl with the basket of flowers.' Bronzed in a manner which would not have shamed Field, and replete with charm. $11\frac{3}{4} \times 9\frac{1}{4}$in. (*Page* 74)

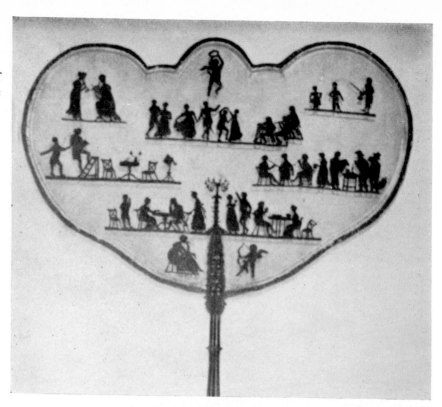

56 F. A. Gray. A pair of handscreens painted as 'The Pleasures of the Town'

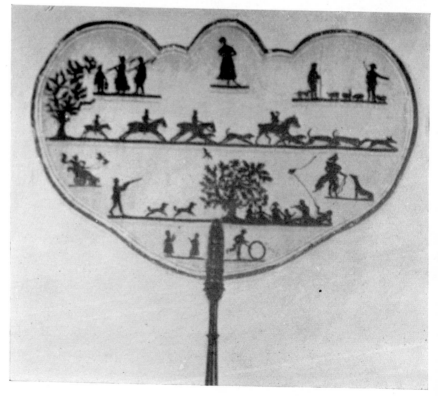

and 'The Pleasures of the Country'. (*Page* 84)

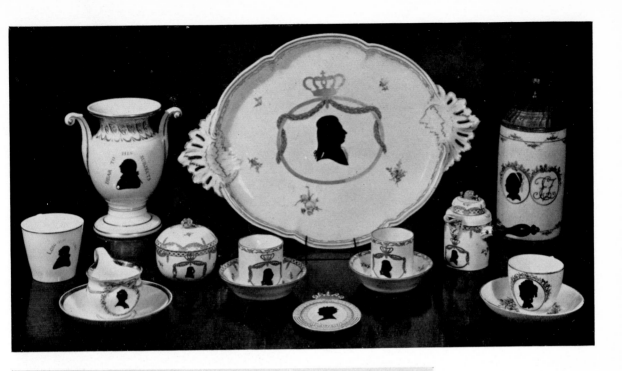

57 A collection of profile porcelain. (*Page* 89)

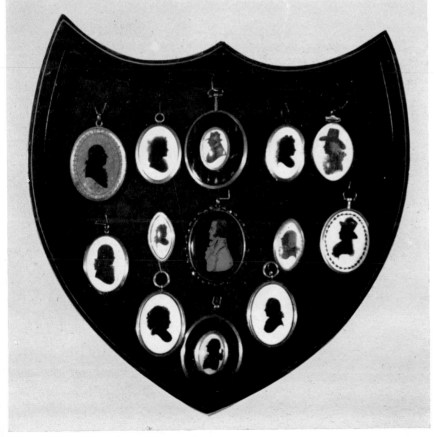

58 A collection of jewellery miniatures. $11\frac{1}{2}$ × $10\frac{1}{2}$in. (*Page* 84)

59 John Field. A landscape, similar to his Royal Academy exhibits, and painted on composition. (*Pages* 70, 85)

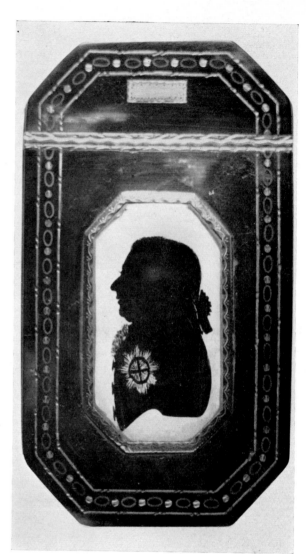

61 Carl Christian Rosenberg. A particularly fine snuff-box of tortoiseshell inlaid with silver and gold and inset with a portrait of the Prince Regent by Rosenberg, circa 1790. The box measures 3¾ × 2in. From the Duke of Buckingham's Collection. (*Page* 84 *and see plates* 36 *and* 37)

OPPOSITE
62 Unknown artist. An ivory shuttle-shaped patch-box inset with a portrait of an officer, his uniform painted in colour. A secret spring releases Mary and her little lamb. 2 × 4¾in. (*Page* 84 *and see plates* 36 and 37)

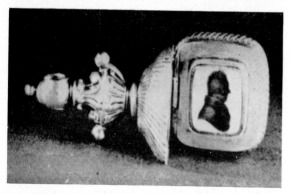

60 Miers and Field. A secret seal. The portrait of a gentleman is signed *Miers & Field*. (*Pages* 59, 92)

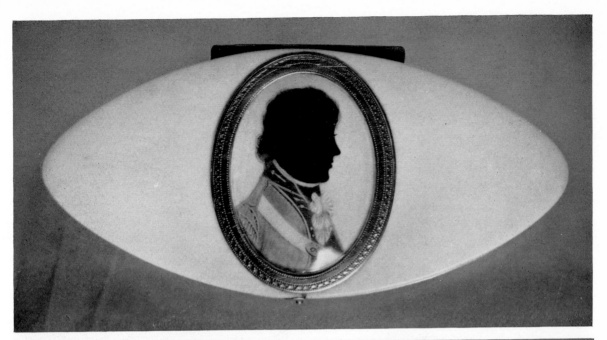

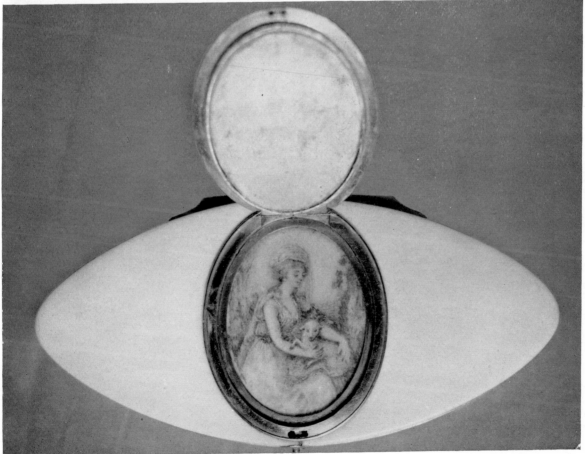

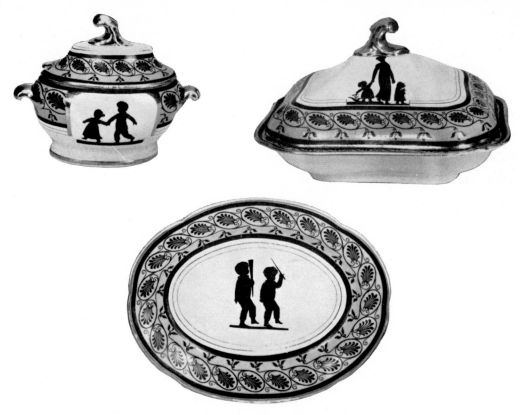

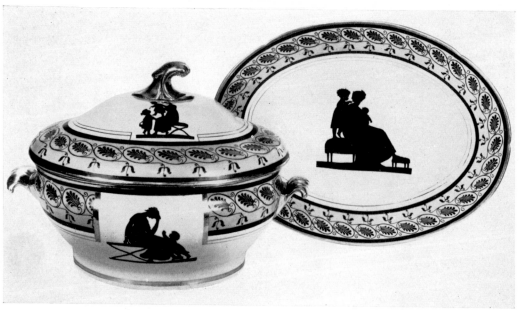

63, 64 OPPOSITE The Angerstein dinner service. (*Page* 89)

65 Phil May. Three Covent Garden characters
painted in 1894. (*Page* 86)